IMAGES
of America

CARLSBAD

IMAGES
of America

CARLSBAD

ague-Bentley

I A
N G

Published by Arcadia Publishing
Charleston, South Carolina

Printed in the United States of America

Library of Congress Control Number: 2008935194

For all general information contact Arcadia Publishing at:
Telephone 843-853-2070
Fax 843-853-0044
E-mail sales@arcadiapublishing.com
For customer service and orders:
Toll-Free 1-888-313-2665

Visit us on the Internet at www.arcadiapublishing.com

*History cannot give us a program for the future, but it can give us a fuller understanding
of ourselves, and our common humanity, so that we can better face the future.*

—Robert Penn Warren

*This book is dedicated to my parents and to all those who have
come before us, shaping our lives into what they are today.*

In memory of John McKaig, Huston Tucker, and Robert Frazee—2009.

CONTENTS

ACKNOWLEDGMENTS

The foundation of this photograph book was made possible by the collection from the Carlsbad History Room at the Carlsbad City Library. Thanks go to Glynn Birdwell and Aspen Hill for helping select photographs for the book. Thanks also to Susan Gutierrez Schnebelen and to members of the Carlsbad Historical Society for providing a place to dig up the past.

Special thanks go to Jack Greelis, who helped track down the best photographs, and to Tara T. Sullivan for making them something that will be enjoyed for years to come.

Thanks go to those who took the time to share their photographs and their stories that make up the history of Carlsbad: Janet Detwiler McKaig, whose parents owned a photography studio downtown, and her husband, Johnny McKaig, a Carlsbad volunteer fireman and downtown business owner; Pat McClellan Baldwin, whose family roots run to the formation of Carlsbad, and her husband, Bill Baldwin, one of the forces behind the city's incorporation; Shelley Hayes Caron for the information on the original Marrón family; Al Certa Jr. and Marlene Fosselman of the San Luis Rey Band of Mission Indians; Susan Kelly and Joyce West Smith; Lizbeth Ecke with the Carltas Company and the Flower Fields; Marie Frazee Lawson and Cindy Huntzinger; Angela Holman, Carlsbad Chamber of Commerce; Rachel McQuire, City of Carlsbad; Kelly Cain and Lynn Diamond, Carlsbad Police Department; Cody Osburn, Dan Sprague, and Rick Fisher, Carlsbad Firefighters Association; Nicole Knight and John Maffucci, Army and Navy Academy; Alan and Joan Kindle, Friends of Carrillo Ranch; Mick Calarco and Gerry Streff, Leo Carrillo Ranch; Ofie Escobedo and Connie Trejo, Lola's 7-Up Mexican Market and Deli and the Barrio Museum; Jane Schmauss, the California Surf Museum; Randy Laine, action sports pioneer; Barbie Baron, Off Shore Surf Shop; Jeff Warner, Legends Surf and Tamarack Surfboards; Ulises Thomas, Utopiaoptics; Rusty Sharman, personal watercraft pioneer; photographer Patrice Malloy; Don Krager, Photo Art; Jon Kyne and Lornie Kuhle, Bobby Riggs Tennis Museum; and Cliff Bryant. Special thanks to Bruce Santourian for steering us toward the raceway. Thanks to Jeff Grismer, whose family owned the track. Thanks to Jim Nelson and to Rick Doughty, who donated photographs on behalf of martymoates.com, a Web site in memory of racing legend Marty Moates. And last but definitely not least, thanks to Debbie Seracini from Arcadia Publishing and to my mom and son for their support.

INTRODUCTION

Carlsbad is a diverse community.

Located 35 miles north of San Diego, the coastal city of Carlsbad encompasses a unique variety of terrain within a 40-square-mile radius, from rolling hills of farmland to the coastal bluffs above the blue Pacific. Today each community within the city has its own distinctly different feel, with the village still actively serving as the heart of the city.

Once a quiet coastal community known for its ranching and farming of avocados and flowers, today Carlsbad is a bustling suburban city with family-oriented events and attractions.

Because of the city's geographical location between Orange County and the city of San Diego and proximity to a county airport, many businesses are also headquartered in Carlsbad.

Carlsbad has grown rapidly since the postwar baby boom years. With a population of 2,500 residents just after the war, Carlsbad grew to almost 7,000 at time of incorporation in 1952.

Today there are more than 100,000 residents and even more during the summer months. As it has since the early days of the town, the sparkling blue Pacific Ocean still draws tourism year-round. Hotels have continued to crop up on the coastal bluffs along historic Highway 101, now called Carlsbad Boulevard.

However, just over the hill, along El Camino Real, the original route used by the Spanish missionaries who first came through the area, there are still links to the past.

Remnants of shells from Native American fishing camps and other Native American artifacts have been found during development of the area around the Agua Hedionda Lagoon, one of three lagoons within city boundaries. The Palamai fishing camp was used by the Luiseño Indian tribe, a tribe given the name by the Spanish explorers who founded the nearby San Luis Rey Mission. In 1769, Spanish explorers Don Gaspar de Portola and Fr. Juan Crespi came through the area, and in 1798, Fr. Fermin de Lasuen established Mission San Luis Rey de Francia, one of 21 set up by the Spanish. The land to the south of the mission was used as ranchland by the missionaries, and the Native Americans were under the control of the mission and often displaced.

After Mexico gained independence from Spain in 1821 and the mission era ended, a Californio by the name of Juan María Romualdo Marrón was granted the Rancho San Francisco, later known as the Agua Hedionda land, by the Mexican government.

After his death in 1853, the majority of Rancho Agua Hedionda was left to his widow and children and was eventually acquired by Francis J. Hinton, a wealthy land and mine owner. It then became part of the Robert Kelly family after Hinton died in 1870. However, La Rinconada de Buena Vista, the most fertile land at the northern boundary along the Buena Vista Creek, near El Salto Falls, remained in the Marrón family.

In 1848, California had become part of the United States, and many had come west in search of the American dream.

In 1881, John Frazier purchased land northwest of Rancho Agua Hedionda, where he subsequently drilled wells to find water.

When mineral and artesian water was discovered and thought to be an exact match to that of water of the famous spa in Karlsbad, Bohemia, the town was named and investors hoped to capitalize on the popularity of the find. Between 1886 and 1887, a group formed the Carlsbad Land and Mineral Water Company. The Carlsbad Hotel was also built in 1887, and tourists began to flock to the area. However, the land boom in California slowed, and by the beginning of the 20th century, Carlsbad was once again a quiet coastal community.

In the early 1900s, the town experienced a rebirth when a new group of investors formed the South Coast Land Company and began to sell subdivided land with newly acquired water from the San Luis Rey River.

In the 1920s, Carlsbad began to flourish as an agricultural community and soon became known as the "Home of the Avocado" and later "the Flower Capital," a title shared with neighboring Encinitas. By 1925, the population of Carlsbad had swelled to 600.

In 1930, the Carlsbad Hotel and Mineral Springs opened and began attracting many from the Hollywood area, who stopped at "the World-famous Twin Inns" on the way to or from Los Angeles or Agua Caliente in Baja California and later the track in Del Mar.

The Depression took its toll on the area, but after World War II, the postwar baby boom led to rapid growth everywhere, and Carlsbad was no exception. By 1943, there were approximately 2,500 people living in Carlsbad.

As the land became more and more valuable, the ranches and farms, groves, and flowers began to disappear, giving way to homes and new businesses.

In 1951, residents began talk about the annexation of a coastal strip of land in Carlsbad to Oceanside. A vote in the spring of 1952 ended in a tie of 45-45. But soon after, in 1952, residents voted to incorporate. By then, the new city had nearly 7,000 people.

Soon after incorporation, a city council was formed, the residents began to exercise their voting rights, and a new source of water was brought in from the Colorado River. Carlsbad residents began to feel their newfound independence, as many united to form clubs and organizations to promote their "vision" for the newly formed city.

As Carlsbad continued to grow over the next several decades, a strong constituency began to work hard to rally for open space, parks and trails, and for preservation of the past.

Today, mixed in with the new high-tech business, golf, and tourism industries in Carlsbad are reminders of the past. The Flower Fields still remind locals of days gone by, and tourists still come to see the colorful ranunculus flowers. A drive down Sunny Creek Road, east of El Camino Real, takes visitors back in time. Ranches with old barns and horses sit side by side with working farms, which still dot the hillside among suburban homes. One of the original adobe homes can still be found nestled along the roadside, and it still belongs to the Kelly family.

Just off El Camino Real is Leo Carrillo Ranch, formerly known as Los Kiotes, now a historic park where visitors can see the site of the old Kelly ranch. Just north of there, off Sunnycreek Road, one of the origianl adobes can still be seen. And farther north, the Marrón family's original L-shaped adobe can still be found in Marron Canyon along the Buena Vista Creek.

Carlsbad has changed, but the miles of state-run beaches, three beautiful lagoons, hidden canyons with waterfalls, a dormant volcano, mineral springs, Native American artifacts, and recently uncovered prehistoric remains have stood the test of time to serve as a reminder to us that Carlsbad is truly a historic treasure.

One

THE BIRTH OF CARLSBAD

In 1769, Spanish explorers Don Gaspar de Portola and Fr. Juan Crespi came through the area, and in 1798, Fr. Fermin de Lasuen established Mission San Luis Rey de Francia, one of 21 set up by the Spanish. The acres of land to the south were used as ranchland for the mission. But Spanish rule ended in 1821, and in 1842, Juan María Romualdo Marrón was granted 13,311 acres of what was once called San Francisco and was later called Rancho Agua Hedionda by Mexican governor Juan Bautista Alvarado. In 1848, California became part of the United States. When Marrón died in 1853, he left the majority of the property to his wife, Felipa Osuna de Marrón, and their four children and a smaller portion, often referred to as the planting lands of the La Rinconada de Buena Vista, to his brother, Silvestre Marrón.

In 1860, Felipa and her children mortgaged the rancho to Francis J. Hinton, who eventually took over all but the 362 acres in the northern part of the property. Hinton died in 1870, and Robert Kelly, the property caretaker or majordomo, took over. In 1880, Robert Kelly granted right-of-way to the railroad, and progress began to take over.

The birth of Carlsbad came when, in 1881, John Frazier purchased land just northwest of Rancho Agua Hedionda, where he dug several wells.

When he discovered mineral water in 1883, he began to give it out to train passengers. The stop was originally named Frazier's Station; only later was it changed to Carlsbad when the town was named.

After testing, the water was found to have a mineral content similar to that of the spa town Karlsbad, Bohemia, and investors named the town. In 1886, Samuel Church Smith founded the Carlsbad Land and Mineral Water Company along with Gerhard Schutte, D. D. Wadsworth, and Henry Nelson. Together, in 1887, they purchased 270 acres of the coastal land for investment opportunities.

After initial success, hard economic times soon followed in the United States, and California was no exception.

By 1890, land values had dropped and many had left the area, and by the end of the century, Carlsbad was a much quieter place.

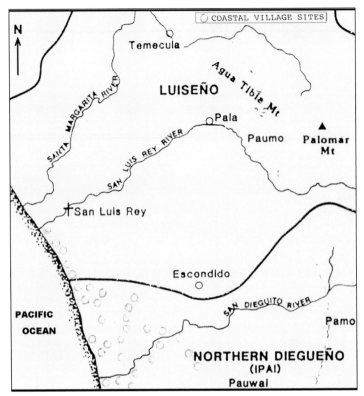

In 1769, the structure of the migratory life known to the Luiseños was lost once they came under the control of the missions and were provided food, shelter, and clothing. The Luiseños were actually part of the Shoshonean family, whose territory was near the San Luis Rey River. The headwater was controlled by the Shoshonean Cupeno and Yuman Diegueños. The Luiseño Indians lived in small villages near fresh water sources. This area was once called Palamai, or "place of big water." Today there are seven bands of Luiseño people. (San Dieguito Heritage Museum.)

In 1821, Mexico gained independence from Spain, and the mission period ended. Secularization and division of mission land then occurred. In 1834, the Mexican governor issued private land grants. Mission San Luis Rey was divided into five separate land grants: Encinitas to the far south, Los Vallecitos to the east, Agua Hedionda, Buena Vista, and Guajome. In 1846, America entered into a war with Mexico, and in 1848, when the war ended, Mexico had to give up much of the land, and Mexican rule over California ended. Native Americans were sent to live on reservations. (Hayes Collection.)

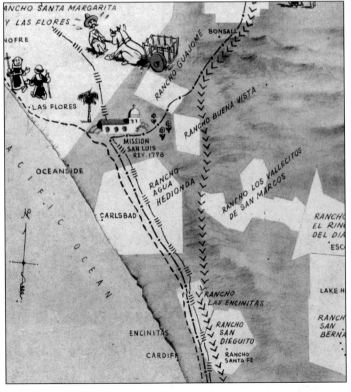

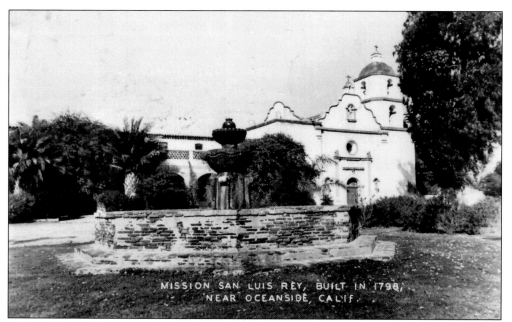

MISSION SAN LUIS REY, BUILT IN 1798,
NEAR OCEANSIDE, CALIF.

Much of the land that is now Carlsbad was once controlled by the missions for use as ranchland. This postcard shows the San Luis Rey Mission, which was built in 1798. The mission was established by Fr. Fermin de Lasuen and would become the richest of all 21 California missions. (Jack Greelis.)

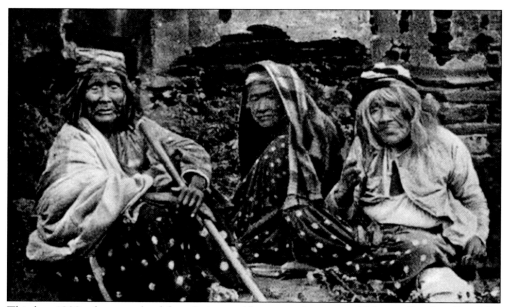

This late-1800s photograph of three Luiseño elders was taken around Mission San Luis Rey. The woman on the left (with the walking stick) was known among the San Luis Rey Band of Mission Indians as "Chamguinich" and was also given a Spanish name of Tomasa by the *padrone* of the mission at the time of baptism. She lived to be 105 years old, having lived most of her life at the nearby Luiseño village of Waxawmay (Guajome). The clothing worn by the women is believed to have been donated by the mission. (San Luis Rey Band of Mission Indians.)

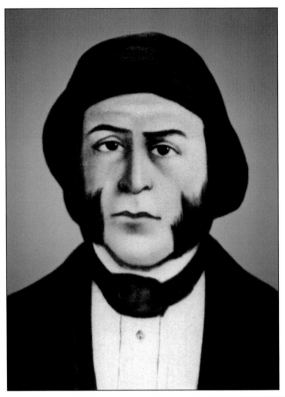

Juan María Romualdo Marrón, born in 1808, was a rancher and politician who was granted the more than 13,000 acres now known as Rancho Agua Hedionda by the Mexican government in 1842, when Spanish control ended. When Juan María Romualdo Marrón died in 1853, the majority of the land was transferred to his wife, but he left a portion of the land, 362 acres on the northern border of Rancho Agua Hedionda, to his younger brother, Silvestre Marrón. (Carlsbad History Room, Carlsbad City Library.)

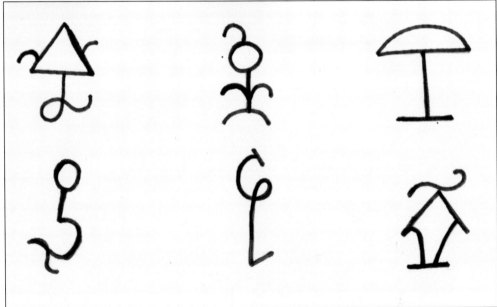

The Marrón family used the following symbols for branding cattle, which initially roamed all of Rancho Agua Hedionda: family brands are, clockwise from top left, Jose Marrón, 1854; Juan María Marrón, son of Silvestre, 1861; Felipa Osuna de Marrón, 1855; María de la Luz Marrón de Estudillo, 1855; Valenzuela de Marrón, 1881; and Leonora Osuna de Marrón and Abram Marrón. (Shelley Hayes Caron.)

Silvestre Marrón, born in 1827, was the much younger brother of Juan María Romualdo Marrón and worked for his brother. He was given 362 acres of the most fertile land on the northern border of Rancho Agua Hedionda by Juan María Romualdo Marrón when he died in 1853. Silvestre Marrón lived on the property until he died in 1906. (Carlsbad History Room, Carlsbad City Library.)

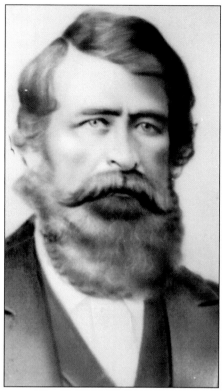

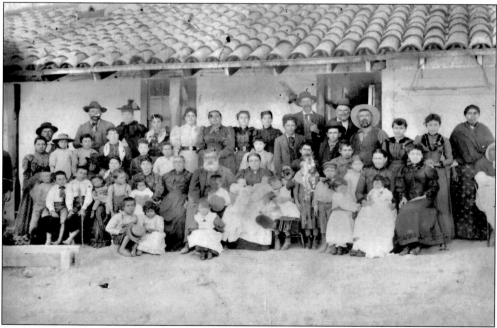

Hidden under trees on the La Rinconada de Buena Vista portion of Rancho Agua Hedionda, almost 362 acres on the northern border of Rancho Agua Hedionda, is an adobe house from the 1800s referred to as the L-shaped adobe. This Silvestre Marrón family group photograph was taken there in 1895. (Hayes-Marrón Collection.)

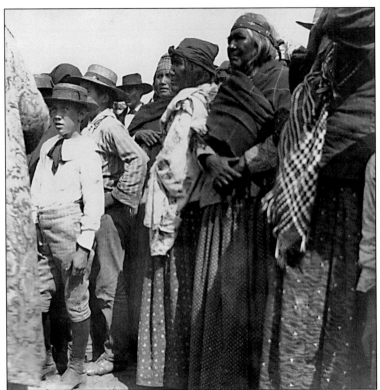

Fiestas, such as the one shown here, were often held at Mission San Luis Rey in the early 20th century by the Luiseño Indians. They were thought to be held twice a year to celebrate the summer and winter equinox. (Rudy Carpenter.)

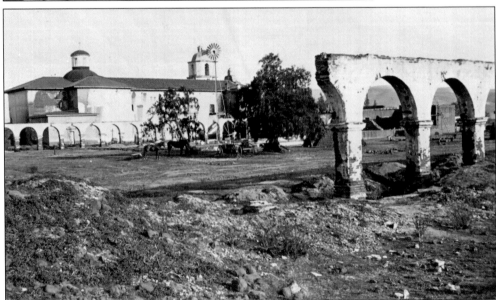

Mission San Luis Rey, built in 1798, brought many changes in the way the Luiseños lived. The Spanish set up the mission system to protect their claim to the land and to bring the Catholic religion to the natives. The Mexican government gained control over the area, and the mission period ended in 1834. California became part of the United States in 1848. The mission is pictured around the end of the 19th century. It was restored years later. The oldest pepper tree still remains on the ground. (Hayes-Marrón Collection.)

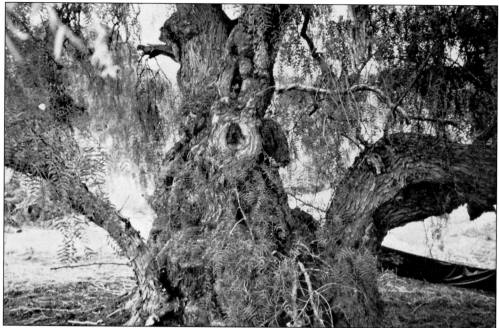

This pepper tree is special to the native people who lived in the area, as it is part of the original pepper tree located at the Mission San Luis Rey. A local Native American woman by the name of Librada Lorenza Garcia was born under this pepper tree near the L-shaped Marrón adobe. She recounted the story for years, and both the tree and the adobe still stand today. (Melvin Sweet.)

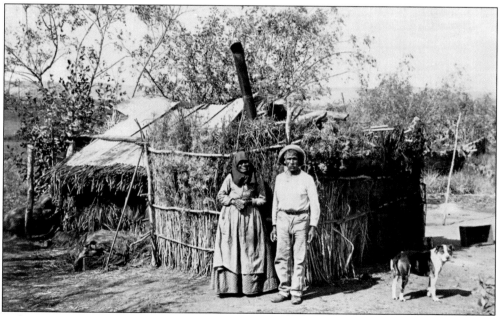

Refugia Ortiz and Honorato Garcia's daughter Librada was born under the pepper tree on the northern portion of the Rancho Agua Hedionda property near the L-shaped Marrón adobe. She died in 1893 at the Rancho Buena Vista Adobe in Vista, California. The Luiseño huts were brush-thatched structures with vents for releasing smoke. (Hayes Collection.)

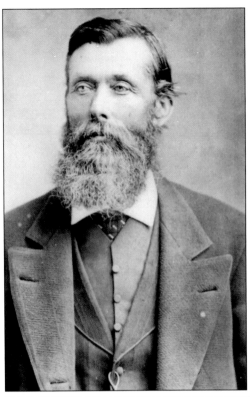

Born in 1825, Robert Kelly became the property caretaker for Francis Hinton after moving to San Diego in 1852. When Hinton passed away in 1870, he left his portion of Rancho Agua Hedionda land to Kelly. (Carlsbad History Room, Carlsbad City Library.)

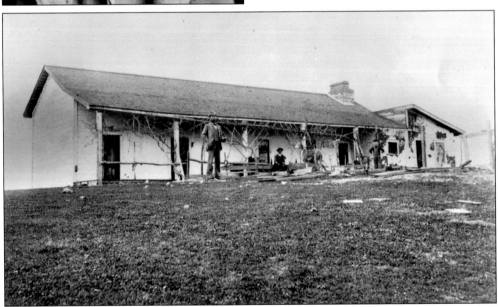

Robert Kelly acquired the Rancho Agua Hedionda land from Francis J. Hinton in 1870, when Hinton died. He then granted a coastal right-of-way to the Southern California Railway in 1880. After his death, the sons and daughters of Matthew Kelly inherited the land. Pictured in this 1893 photograph are the heirs to the land: Charles Kelly, Herbert C. Kelly, six years old at the time, and an unidentified sheepherder with a Great Dane. (Carlsbad History Room, Carlsbad City Library.)

Matthew Kelly, born in 1822, was Robert Kelly's older brother, who married Emily Porter and built Los Kiotes. He died in 1885. (Carlsbad History Room, Carlsbad City Library.)

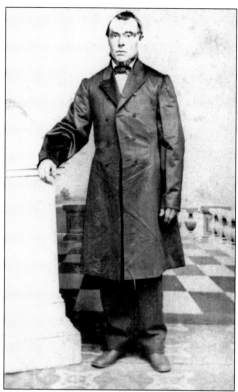

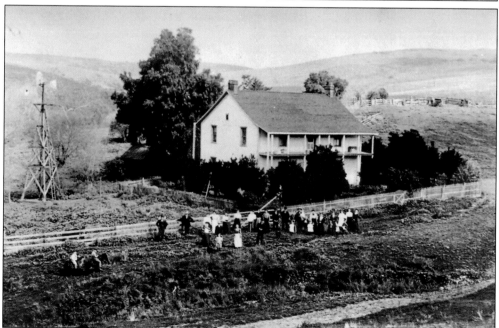

Los Kiotes was home to Matthew Kelly, Robert Kelly's brother. He reportedly built a home in 1868 and moved his family into it in 1869. In this 1906 photograph, the Kelly family is said to be gathering for a family reunion picnic at the second home built by Matthew a few years after Los Kiotes. (Carlsbad History Room, Carlsbad City Library.)

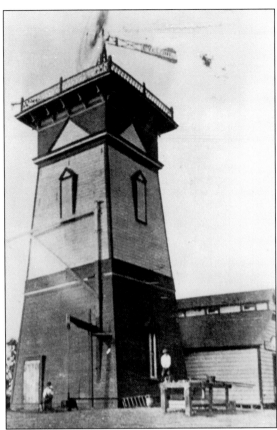

In 1881, John Frazier bought property just northwest of Rancho Agua Hedionda. In 1883, he discovered water and gave it out to passengers of the train. The stop was later named Frazier's Station. The well initially went to a depth of 450 feet in order to pump what turned out to be mineral water. (Carlsbad History Room, Carlsbad City Library.)

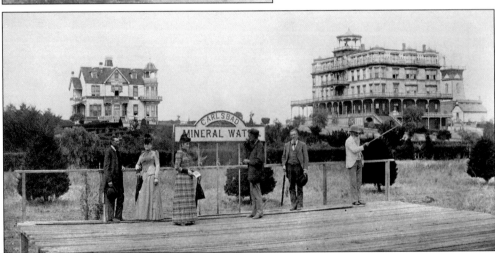

In 1883, John Frazier discovered water on his property. Frazier's Station later became Carlsbad when the water Frazier discovered was found to be similar to water from a famous European spa in Karlsbad, Bohemia. Pictured in this 1890 photograph are, from left to right, John Frazier, his wife and daughter, Gerhard Schutte, Samuel Church Smith, and David D. Wadsworth. Train passengers were able to sample the water from the faucets seen under the sign in the middle of the photograph. The Carlsbad Hotel (right) and Twin Inns are in the background. (San Diego Historical Society.)

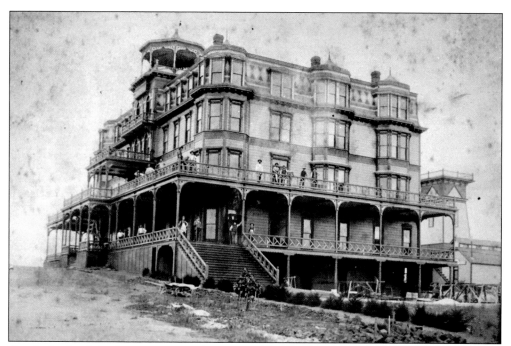

On the heels of the famous water with purported healing powers, the Carlsbad Hotel was built in 1887. At a cost of $50,000, the hotel was expensive to build at the time. The hotel burned down in 1896, when a fire was allegedly set by a disgruntled former employee. Behind the hotel are a bathhouse and the famous water tower of John Frazier in the background. (Carlsbad History Room, Carlsbad City Library.)

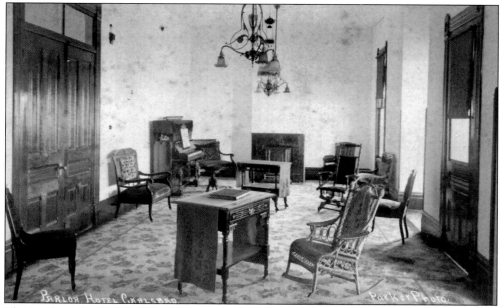

The inside of the Carlsbad Hotel was rarely photographed, but this 1888 photograph is thought to be that of the parlor room at the hotel. The elegance of the time is reflected in the decor and the fact the hotel had paneled doors, a piano, and ornate light fixtures hanging from the ceiling. (Carlsbad History Room, Carlsbad City Library.)

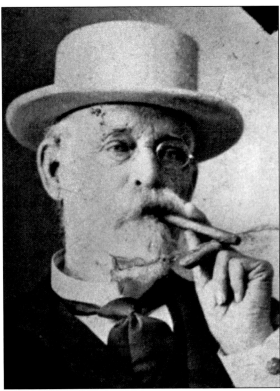

Former Yankee and Midwesterner Samuel Church Smith was one of the founders of Carlsbad. In 1886, Gerhard Schutte convinced him, along with Harry Nelson and David D. Wadsworth, to capitalize on the success of the mineral water and form the Carlsbad Land and Mineral Water Company. (Carlsbad History Room, Carlsbad City Library.)

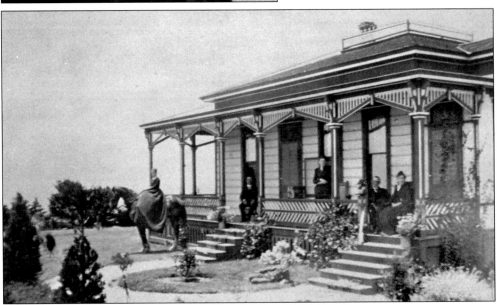

Samuel Church Smith lived in Carlsbad until 1890 and then moved to San Diego when real estate values dropped and the Carlsbad Land and Mineral Water Company fell on hard times. Pictured at the home of Samuel Church Smith are, from left to right, Lillian Smith (Reeder), George Smith, Elmer Church Smith, Samuel Church Smith, and Louise Lehman Smith, who married Samuel Church Smith around 1887. The building is now the Carlsbad Historical Society. (Carlsbad History Room, Carlsbad City Library.)

Gerhard Schutte was born in Oldenburg, Germany, in 1839 and immigrated to the United States when he was 17 years old. He moved west to invest in the land boom going on in California at the time. When he found Carlsbad, he set up the Carlsbad Land and Mineral Water Company, of which he became president. (Carlsbad History Room, Carlsbad City Library.)

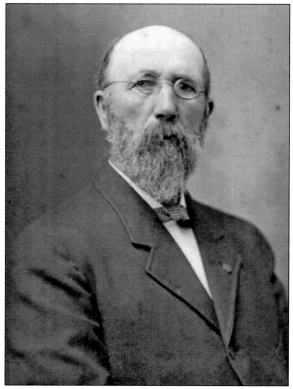

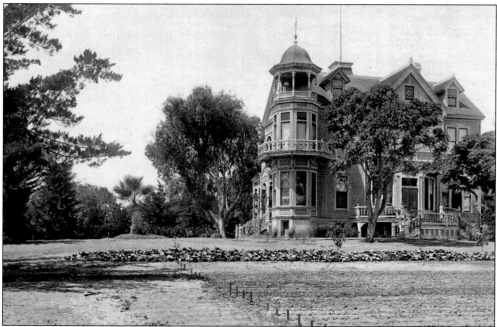

Gerhard Schutte lived in this home on the corner of Elm Avenue (what is now Carlsbad Village Drive) and Carlsbad Boulevard from 1894 until he moved to National City in 1906. The home was eventually purchased by Eddie Kentner and his wife, Neva, and became the popular Twin Inns. (Carlsbad History Room, Carlsbad City Library.)

It has been said that Carlsbad Land and Mineral Water founder D. D. Wadsworth never did live in the home he built, called the "twin" of the Twin Inns, located on the corner of Grand Avenue and Carlsbad Boulevard. However, he did make his home available to others before it was eventually torn down. Pictured in the late 1800s is the family of Idella Savage, who lived in the home several years. Idella was married to R. G. Chase, one of the first postmasters and owner of the town's first general store. (Both, Pat and Bill Baldwin.)

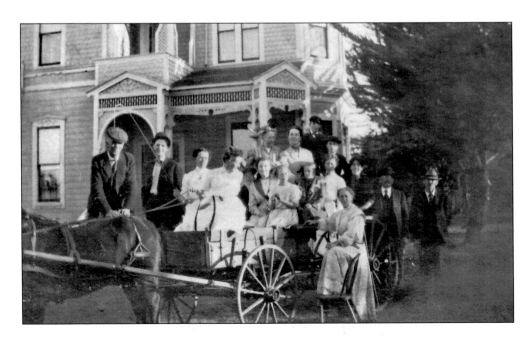

As the town grew, so did the needs of the residents. The Shipleys, the Shaws, and the Ramseys were all founding members of the village area's first church, St. Michael's, located on Oak Avenue and Lincoln Street. The Shipleys lived in Samuel Church Smith's former cottage home. Pictured in the late 1800s is Florence Shipley, the daughter of Alexander and Julia Shipley. The Shipleys later donated land on Carlsbad Boulevard and Beech Street for the California State Forestry Department to build a fire station. (Carlsbad History Room, Carlsbad City Library.)

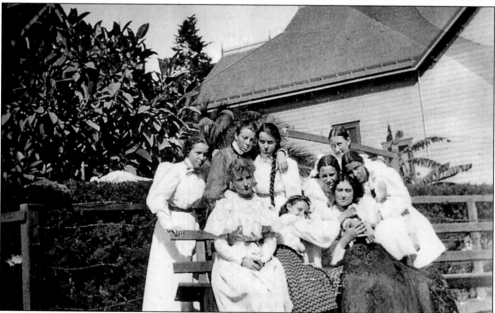

Years after this school-girl photograph was taken, Florence Shipley married Hugh Magee and moved away, but eventually she returned to her childhood home. When she passed away years later, she donated the home to the city. It is now the Carlsbad Historical Society in Magee Park. Shipley is pictured third from the left in the back row along with her school friends from Our Lady of Peace Catholic School in San Diego. (Carlsbad History Room, Carlsbad City Library.)

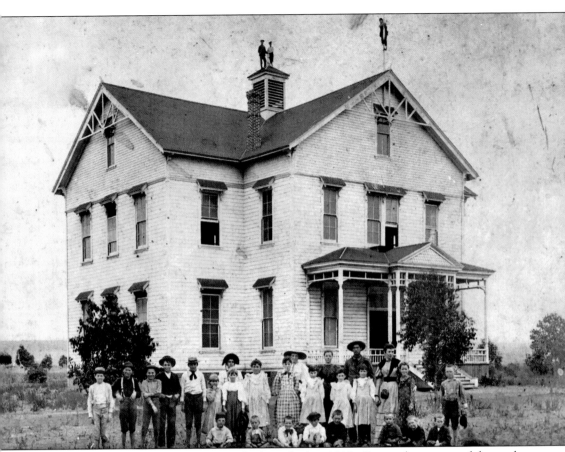

Carlsbad School on Pine Avenue was built in the late 1800s. Pictured are some of the students posing for their official class photograph. Two boys made their way to the roof and are posing with the bell cupola. Pictured in the late 1880s are, from left to right, (first row) Budd Schiefer, Charlie Patterson, Saban Johnson, Oscar Schutte, Herman Kock, Alvin Nelson, Frank Kock, and Carleton Schiefer; (second row) Della Schutte, Myrtle Brown, Lena Patterson, Ida Johnson, Lola Pratt, Emma Johnson, and Lulu Pratt; (third row) Harry Schiefer, Paul Schutte, Frank Shirley, Johnie Langenback, Eugene Pratt, Aurelia Langenback, Louise Crain, Ollie Patterson, William Patterson, teacher Hattie Schutte, Mittie Patterson, and Frank Campbell. On the roof are Bert Patterson and George McCrea (left) and Edward Schutte. (Carlsbad History Room, Carlsbad City Library.)

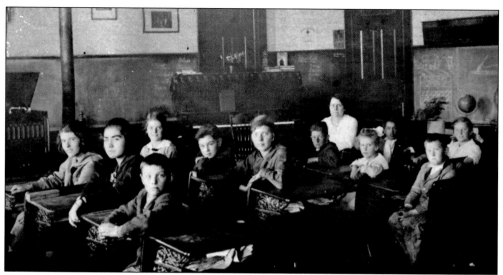

Carlsbad School on Pine Avenue was the first school located in the village. Carlsbad School was a two-story, four-room building constructed with school bonds in the late 1800s. The school was said to be in an isolated area at the time of construction. It was replaced in 1925 by a new school in the same location and later changed names. Fewer children remained in town after the beginning of the 20th century, although others attended another school for children of farming families. Hope School was built in 1872, but that school was farther south, where the La Costa Resort and Spa is now located. The above photograph was taken in 1912 and the one below in 1920. (Both, Carlsbad History Room, Carlsbad City Library.)

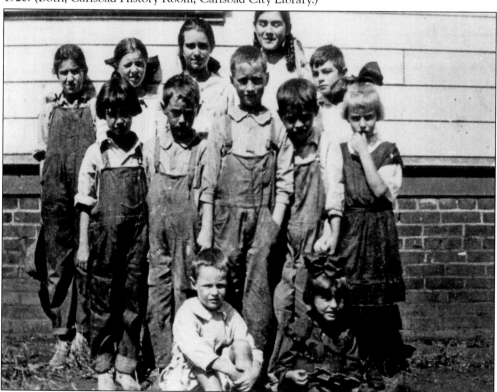

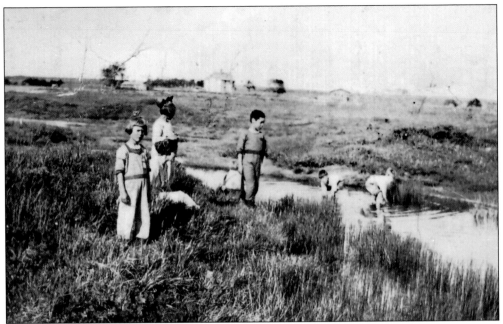

As with the Buena Vista Lagoon, the Batiquitos and Agua Hedionda Lagoon estuaries attract a variety of wildlife. This photograph of local resident Louise Carpenter is thought to have been taken around 1915 near what is now Ponto or Terramar Beach. (Carlsbad History Room, Carlsbad City Library.)

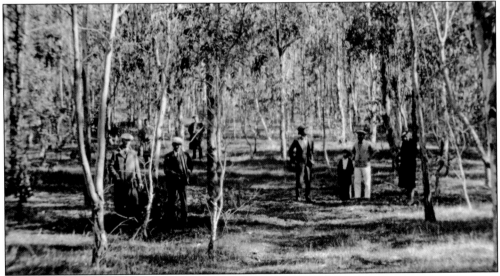

Around the dawn of the 20th century, Pres. Theodore Roosevelt said the country was "running out of trees," so he encouraged the U.S. Department of Interior to outlaw lumbering. Railroad companies were worried, so the Santa Fe Railroad planted 4,000 seedlings for eucalyptus trees in Rancho Santa Fe. F. P. Hosp, an Oceanside nurseryman who saw potential profit in growing the trees, was hired by investors to plant 40,000 eucalyptus trees on 45 acres in the northern part of Carlsbad, near the Buena Vista Lagoon, in 1907. Unfortunately, the trees proved to be useless for railroad ties, as the wood was too brittle. This photograph was taken in 1918. (Carlsbad History Room, Carlsbad City Library.)

Two

The Rebirth of Carlsbad

Around the beginning of the 20th century, the town of Carlsbad was quiet. However, not long after, in 1906, William G. Kerckoff, C. A. Canfield, and Henry Huntington started the South Coast Land Company by acquiring the remaining properties of the Carlsbad Land and Mineral Water Company in the village. In 1919, Neva and Eddie Kentner purchased the Schutte home, already known as the Twin Inns restaurant. The Twin Inns soon became a popular destination for travelers passing through Carlsbad. Meanwhile, Ed Fletcher, the first manager of the South Coast Land Company, arranged to bring water in from the San Luis Rey River and formed the Carlsbad Mutual Water Company in 1919. That arrangement with the City of Oceanside, as well as the climate of the area, brought about the popularity of agriculture in Carlsbad. Many in agriculture, and especially the floriculture business, moved to the area in the early 1920s. By 1925, the population of Carlsbad had swelled to 600.

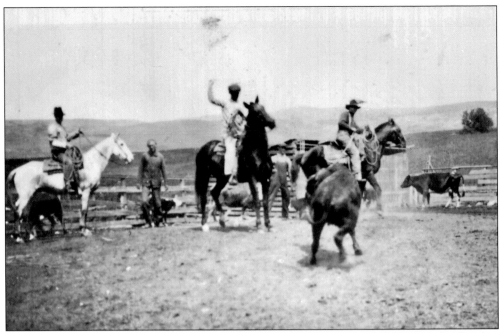

When Robert Kelly died, the Rancho Agua Hedionda land was divided between his brother Matthew Kelly's children. Here in the early 1900s on the ranch of one of the heirs, horsemen are lassoing cattle. (Carlsbad History Room, Carlsbad City Library.)

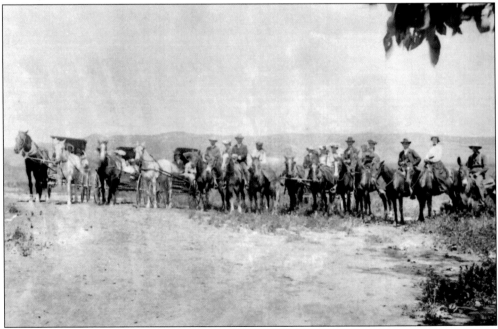

On the ranch of William S. Kelly in 1902–1904, participants gather for a rabbit drive hunting expedition. Included in the picture are Elmore Squires (buggy at left); Mrs. R. J. Kelly (second buggy from left); James and Johanna Kelly (third buggy from left); Matthew, W. S., and Lavinia Kelly (fourth buggy from left); and Chester Gunn and Will, John, Rob, Minnie, and Ethel Kelly (on the horses, in no particular order). (Carlsbad History Room, Carlsbad City Library.)

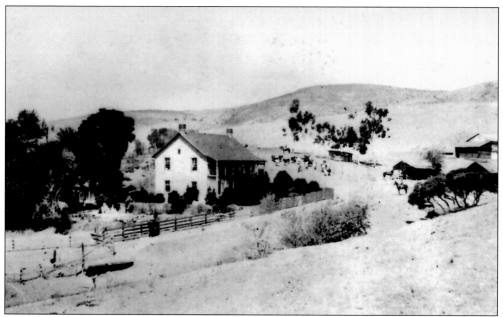

Matthew Kelly homesteaded 10,000 acres south of Rancho Agua Hedionda and built a house called Los Kiotes on his land in the late 1800s. Later, In 1937, actor Leo Carrillo purchased the land. Today portions of the original ranch remain. (Carlsbad History Room, Carlsbad City Library.)

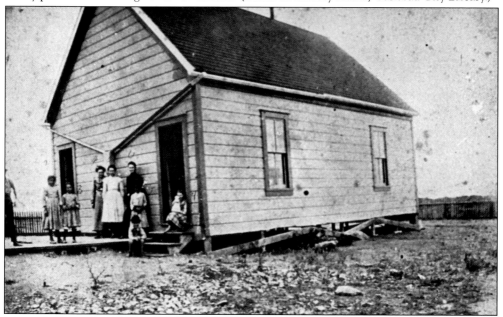

Many of the farming family students outside of town attended Calavera School. The building had once been used to house the old Minneapolis Beach Colony silkworm enterprise near the beach on what is now Cannon Road. The families used horses to move the building north to the school site several miles east of El Camino Real. The school was eventually closed in 1919–1920. Pictured in this 1916 photograph are, from left to right, Ray Borden, Adeline Marrón, Lizzie Kelly, Alice Kelly, Jenny Borden, Felipa Marrón, Forest Borden, Peter Marrón, and Bessie Borden. (Carlsbad History Room, Carlsbad City Library.)

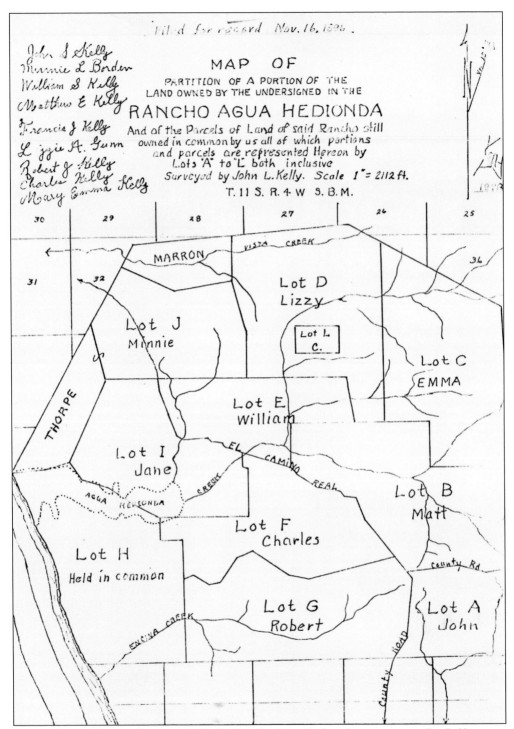

After Robert Kelly passed away in 1896, the Rancho Agua Hedionda property was divided between the children of his brother Matthew Kelly, since Robert Kelly had no children of his own. This map shows the division between the siblings: Minnie, Lizzy, Emma, Thorpe, William, Jane, Charles, Matt, Robert, and John Kelly. (Carlsbad History Room, Carlsbad City Library.)

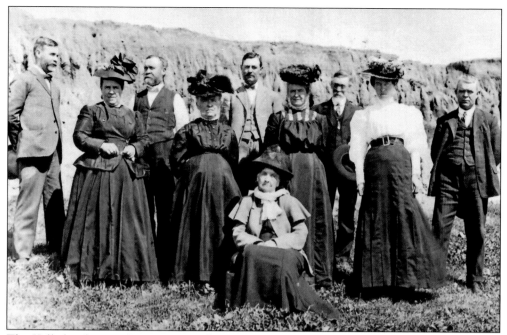

The Kelly brothers and sisters enjoyed an outing in 1909 at the La Costa Beach, now South Carlsbad State Beach. Pictured are, from left to right, (first row) Emma Squires, Elizabeth Gunn, Minnie Borden, Frances Pritchard, and Emily Porter Kelly (front, seated); (second row) Will, Charles, Robert J., Matt, and John. (Carlsbad History Room, Carlsbad City Library.)

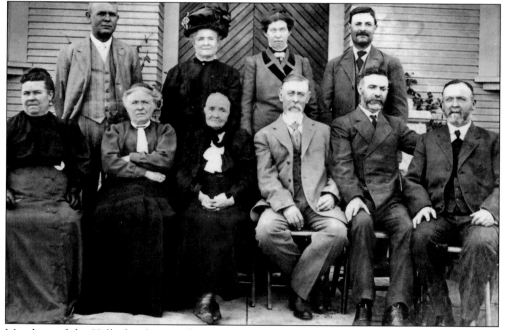

Members of the Kelly family attend services in 1910 at Oceanside Christian Church. Pictured are, from left to right, (first row) Emma, Lizzie, Emily Porter Kelly, William, and Charles; (second row) John, Minnie, Jane, and the youngest son, Robert Kelly. (Carlsbad History Room, Carlsbad City Library.)

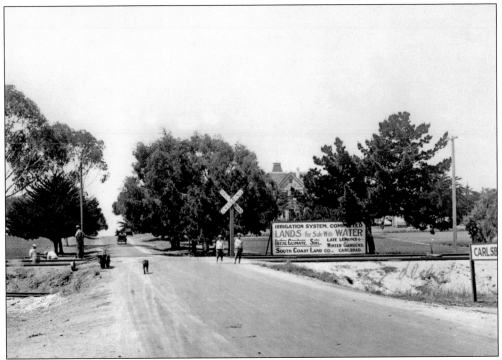

When William Kerckoff, C. A. Canfield, and Henry Huntington founded the South Coast Land Company, they erected a sign on Elm Avenue (now Carlsbad Village Drive) that read "South Coast Land Company, Lands for Sale with Water." They arranged to have water brought in from the San Luis Rey River and promoted farming in the area, as this 1916 photograph shows. (San Diego Historical Society.)

Much of the land in the northern part of Rancho Agua Hedionda was undeveloped in the 1920s. Pictured is the home of Abraham Lincoln Marrón and Jennie Romo Marrón near El Salto Falls. (Shelley Hayes Caron.)

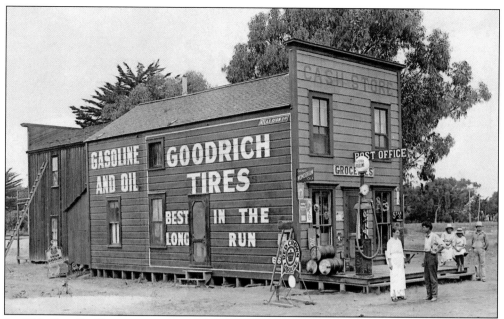

In 1915, Roy G. Chase came to Carlsbad, where he assumed the role of postmaster and then railroad station agent for the Santa Fe Depot. He later became one of the early developers of the town. Pictured from left to right in this 1918 photograph in front of Chase's Store are Idella, Roy, their daughter Dolores ("Dee"), her friend Grace Carpenter, and an employee, a Mr. Roberts. (Pat and Bill Baldwin.)

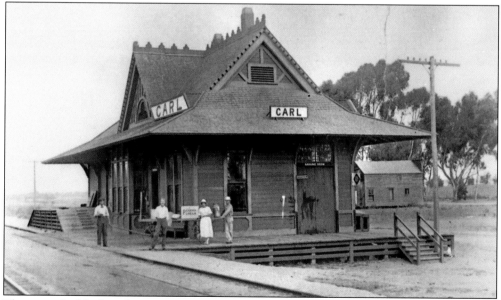

The name Carlsbad on the train depot was changed to "Carl" by the railroad in 1907 to distinguish Carlsbad, California, from the city by the same name in New Mexico. It remained this way for 10 years until the citizens were able to convince the railroad to change it back. R. G. and Idella Chase, who owned the general store and post office, are on the right side of the platform. R. G. founded the Carlsbad Chamber of Commerce and Idella founded the Woman's Club. (San Diego Historical Society.)

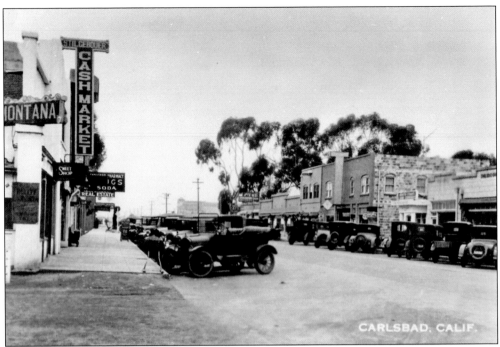

Originally called First Street, State Street was the main highway through Carlsbad. In 1928, U.S. Highway 101 went in, and business was taken away from State Street. This 1920 photograph was taken looking north with the Cash Market and Montana Grill on the left. (Carlsbad History Room, Carlsbad City Library.)

Dee Chase married Dewey McClellan, who went on to become the city's first mayor after working for the South Coast Land Company for many years and serving as president of the chamber of commerce. This photograph was taken in the 1920s. (Pat and Bill Baldwin.)

Ed Kentner with his wife, Neva Kentner, purchased the restaurant in the former Schutte house, on the corner of what is now Carlsbad Boulevard and Carlsbad Village Drive, in 1919. Their Twin Inns restaurant became "world famous." They had five children and lived in the home above the restaurant. (Carlsbad History Room, Carlsbad City Library.)

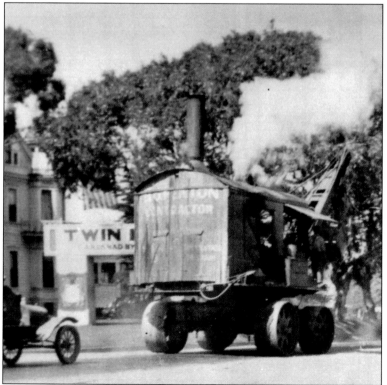

It wasn't unusual in the 1920s to see a large tractor or farm wagon driving east on Elm Avenue toward the farms, like in this photograph. Behind the tractor is the Twin Inns restaurant on the corner of Carlsbad Boulevard and Carlsbad Village Drive. The restaurant had sleeping quarters upstairs where the owners, the Kentner family, lived. (Carlsbad History Room, Carlsbad City Library.)

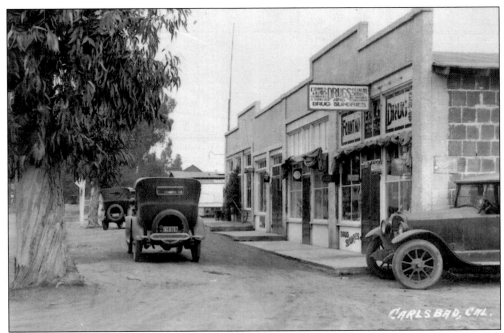

Many of the streets were yet unpaved in the 1920s. City founders planted trees to mark the streets. Here on Elm Avenue looking east toward the railroad tracks, it is possible to see the drugstore with a soda fountain on the corner. Soda fountains in drugstores were typically gathering places for community members. (Carlsbad History Room, Carlsbad City Library.)

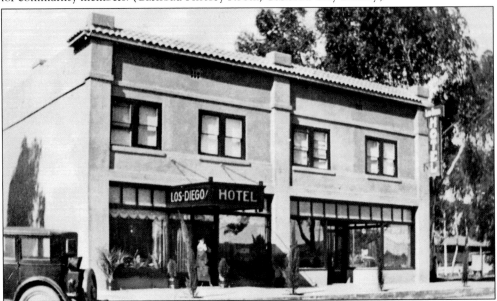

The rebirth of the town and the building boom in Carlsbad came after water was brought to the city from the San Luis Rey River in the early 1900s. One of the first hotels in the area, named the Los Diego Hotel because of its location between Los Angeles and San Diego, was located at the southwest corner of what are now Grand Avenue and State Street. It was built by R. G. Chase, one of the first developers in Carlsbad. The hotel now houses restaurants and businesses and has since been renamed the Plaza de la Fuente. (Carlsbad History Room, Carlsbad City Library.)

Three

FROM BARRIO CARLOS TO CARLSBAD BARRIO

Descendants of some of the early pioneering families are still in the area. The oldest neighborhood in Carlsbad is located just south of the village. Barrio Carlos started as a tent city for workers in the area. The first families to settle in the neighborhood were the Ramirez and Pablo Trejo families. The Ramirez family built a home on the southwest corner of what are now Walnut Avenue and Roosevelt Street in 1918, and the Pablo Trejo family built one on the northwest corner.

By 1924, the Acuna, Mata, Aguilar, Martinez, Soto, Gastelum, and Cantabrana families had moved to the Barrio, as well as the Villasenor, Florez, and Alcaraz families.

Life in the Barrio was all about "comunidad y familia," as families looked out for one another.

However, when the Great Depression hit, some of the founding families headed elsewhere to find work. In 1935, the Mexican and American governments made an agreement to pay for the transportation of any former citizen of Mexico who wished to return home for work, but the catch was they could not return to the United States.

During World War II, however, with many of the men off to war, the government came up with a bracero program to bring field workers from neighboring Mexico back under contract. Many helped rebuild the Barrio community, such as the Reverend John Henley and his wife, Ruth. Many would eventually lean on the services of the nearby Boys and Girls Club.

Most of the action of Carlsbad Barrio centered around the markets and pool hall on Walnut Avenue and Roosevelt Street, then Second Street. However, over the years, residents of the neighborhood knew no boundaries, and many became involved in civic and community organizations and ran businesses both in and out of Carlsbad.

In 1943, Reyes and Dolores Jauregui bought a small grocery store on the northeast corner of Walnut Avenue and Roosevelt Street. Dolores's brother, Baltazar, ran Aranda's Market across the street. When he passed away, Dolores ("Lola") inherited the business. The Aguilars opened the Red and White market on State Street; Juanita and Refugio Rochin and Manuel Castorena owned C&R Provisions. The Rochins later opened the popular Acapulco Gardens in nearby Oceanside, and Castorena went on to become mayor of Carlsbad.

Although members of the oldest neighborhood in the village have branched out into the community over the years, many have left their hearts on the corner of Walnut Avenue and Roosevelt Street, in the Barrio.

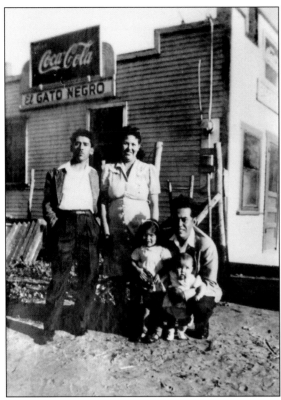

El Gato Negro restaurant, owned and operated by the Alcaraz family, was the first restaurant in the Barrio and was located on Second Street, now Roosevelt Street. Pictured in the 1940s are Catarino Amador (left) and his wife, Elvira Herrera, with their children, Linda and baby Virginia, and Elvira's brother (right). Ruth Alcaraz (Flores) would often watch the children (Carlsbad History Room, Carlsbad City Library.)

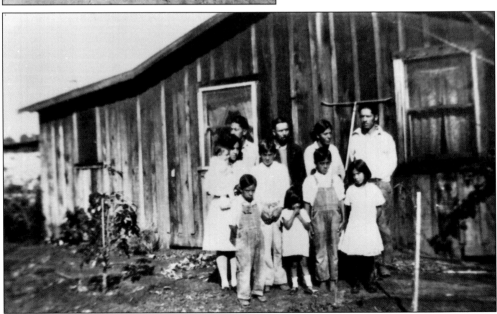

One of the first families in the Barrio was the Acuna family. Pictured in the 1930s are, from left to right (first row) Elijo, or Porky; Benacio, or Ben; Carmen; Leopaldo, or Mike; and Alice; (second row) baby Gregory; mom Annie; father Alberto; Nemesia Trejo-Acuna, and Tomas. Benacio, or Ben, eventually became actively involved in the community, helping build parks and run baseball and softball programs. (Carlsbad History Room, Carlsbad City Library.)

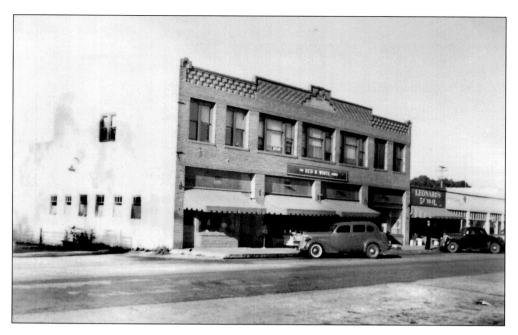

The Aguilars had a popular store in the 1930s in the Killian Building on the west side of State Street called the Red and White market. The building still stands. Pete Aguilar sold it in 1958 to Anthony Spano. The markets still exist in Oceanside and are still in the Spano family. (Both, Carlsbad History Room, Carlsbad City Library.)

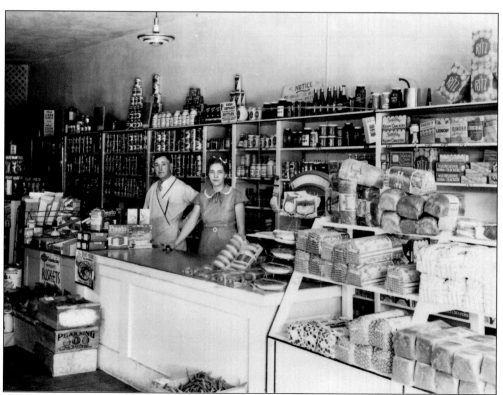

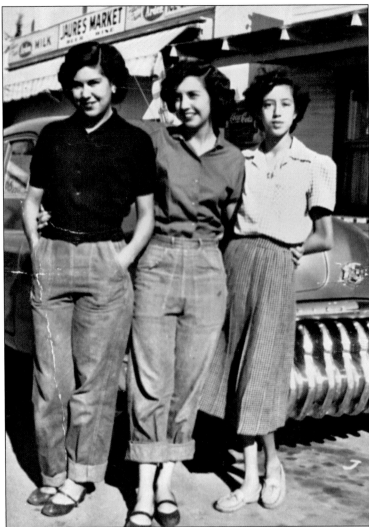

From left to right, sisters Ofie, Connie, and Frances Jauregui-Moreno pose in front of their parents' market in 1951. The sisters went on to remodel and open their own business by adding a deli and called it Lola's 7-Up Mexican Market and Deli, after their mom's and uncle's store. (Ofie Escobedo.)

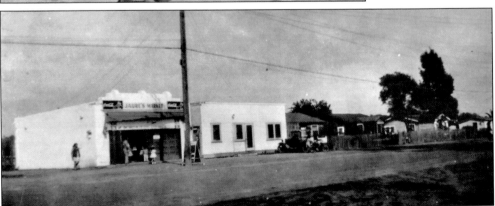

Reyes and Dolores "Lola" Jauregui bought a small grocery store on the northeast corner of Walnut Avenue and Roosevelt Street in 1943, and Jaure's Market became the hub of activity, often called the "heart of the Barrio." (Ofie Escobedo.)

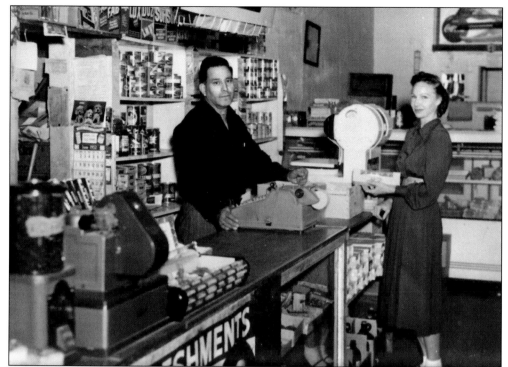

Aranda's Seven-Up Market was also in the heart of the Barrio on the northwest corner, as this 1940s photograph shows. Baltazar Aranda, Lola's brother, owned the first Seven-Up Market, which was later named Lola's. The market had been the first pool hall in the Barrio, owned by the Villasenor and Gastelum families. When Baltazar died, Lola Jauregui inherited the business. (Both, Ofie Escobedo.)

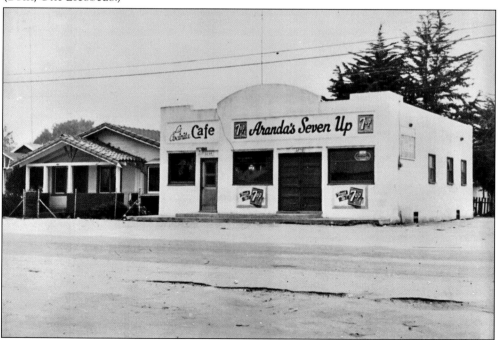

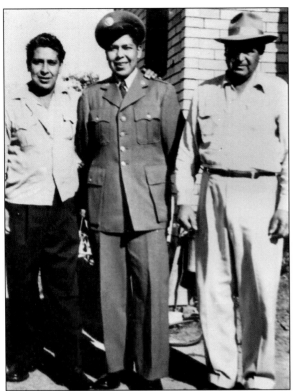

Pete Sotelo (right) is pictured with sons Jimmy (left) and Arthur (center). Many of the men from the Barrio went off to war. As a result, a program was developed by the government to bring Mexican citizens to the United States to work as replacement for the labor. (Barrio Museum.)

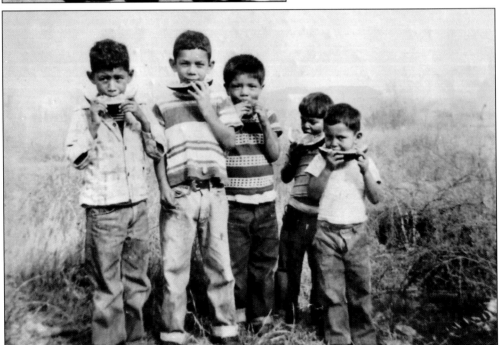

Many Carlsbad Barrio children played together on the streets, as they were often uncrowded. Pictured eating watermelon are, from left to right, Steve Acuna, Ernie Merchado, Manuel Anaya, Peter Lopez, and Ronny Davis. (Barrio Museum.)

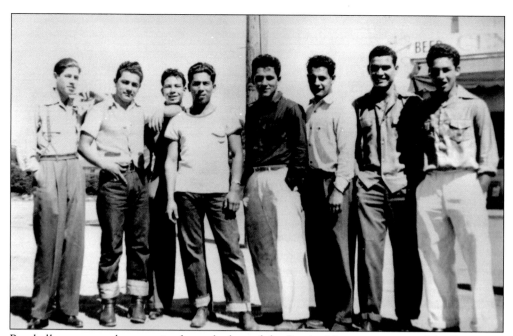

Baseball was a popular sport in the early days of the Barrio. Here young men of the Barrio are pictured at a softball team gathering in the 1940s. They are, from left to right, Tony Grijalva, Nacho Herrera, Alfonso Flores, Treno Munoz, Mike Acuna, Tony Davila, Bobby Dyke, and Jenary Trejo. (Barrio Museum.)

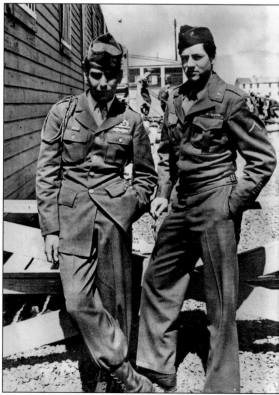

Mike Sainz returned to the Carlsbad Barrio neighborhood development after the war. As a paratrooper during World War II, he fought in such high-profile battlegrounds as the Battle of the Bulge. He was with the 82nd Airborne and was also part of the famous 117th Airborne, which jumped across the Rhine River as part of the invasion into Germany. Mike Sainz is pictured on the right with a friend during World War II. (Barrio Museum.)

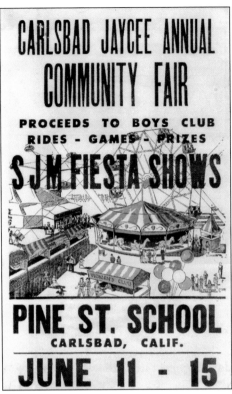

Although the actual Fiesta del Barrio event was organized years later, Pine Street School was the site of an annual Community Fair in 1950, with various activities for all ages. The event was organized by the Woman's Club, one of the first community service clubs in the city. (Barrio Museum.)

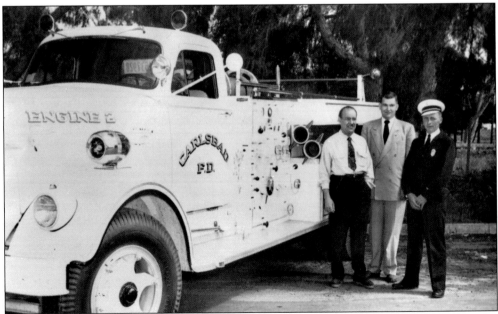

The city's first fire commissioner was Manuel Castorena (left). He was instrumental in the development of the city's fire service and would go on to become mayor in 1958. Here he stands next to the city's first purchased fire engine, Engine 2, a 1954 GMC pumper. It cost the city approximately $4,500. Next to him is Frank Albro from Albro Fire Equipment (center) and fire chief Bob Hardin. (Carlsbad Firefighters Association.)

Four

Agriculture and Floriculture

The history of agriculture followed the history of water in Carlsbad. The town was once known for its dry farming. By 1916, the first avocado groves in the area were planted by Sam Thompson. By 1928, there were several notable growers in the area, including A. W. Theissinger and L. C. Alles. An association of growers was formed, and by the mid-1920s, the annual Avocado Day Celebration was attracting nearly 7,000 people. Carlsbad was known as the "Home of the Avocado."

Luther Gage started his nursery in Montebello, where the main industry was flowers and produce at the time. Urbanization caused growers to look southward for land. Gage moved to Carlsbad in 1921 and started growing winter gladiolus and freesias at his first nursery off Tamarack Avenue. He purchased seeds from friends in England and started the business "Luther Gage Tecolote Giant Ranunculus." Gage is also credited with being one of the first to grow the bird of paradise, along with Clint Pedley and his brother in 1934. All have been credited along with Donald Briggs for the flower's popularity. The bird of paradise is now the city's official flower and is pictured on the city seal.

Gage hired Earl Frazee to work for him, but eventually Frazee started growing on his own and talked his brother, Frank, into the business. Earl Frazee started out as a foreman for Luther Gage in his flower business. Edwin, Frank's son, had also been interested in the ranunculus flower since the age of 16, when he planted his first crop. Edwin later became the only commercial grower of the ranunculus in the United States. Edwin's brother, Robert, became Carlsbad's mayor and a state assemblyman. Like Gage, Harry Bailey also came from Montebello. In 1923, he began growing, among other flowers, ranunculus.

Also in 1923, Paul Ecke Sr., a nurseryman from Los Angeles, brought his business to the area and based it in Encinitas, where he started growing poinsettias in neighboring Carlsbad. E. P. Zimmerman arrived in 1924 and was known for his horticulture skills, growing as many as 30,000 clivia plants, and a few years later, Charles Ledgerwood and E. C. Hummel came to town.

After World War I, many Japanese vegetable growers also came to Carlsbad. Some left, but others returned after World War II. Today families like the Ukegawas are still growing in Carlsbad and are involved in many of the familiar businesses, such as the popular strawberry fields located on hundreds of acres across from the power plant, where locals and tourists come every spring and summer to pick their own strawberries.

CARLSBAD
· BY THE SEA
Home of the Avocado

NORTHERN SAN DIEGO COUNTY
CALIFORNIA

The Avocado Festival Chamber of Commerce brochure in 1930 featured local resident Pat McClellan, now Pat Baldwin. Her father, Dewey McClellan, who worked for South Coast Land Company, became the first mayor of Carlsbad after incorporation. Her grandfather R. G. Chase ran the first general store and other buildings, such as Los Diego Hotel. (Pat Baldwin.)

The annual Avocado Festival drew thousands of people to Carlsbad in 1923. It was held on the first Saturday of every October and featured music, inter-city baseball games, and, of course, avocado-flavored soup, salad, cake, and ice cream. The Avocado Growers Club had grown to a membership of 90 and started the event, which would run from 1923 until just before World War II. (Carlsbad History Room, Carlsbad City Library.)

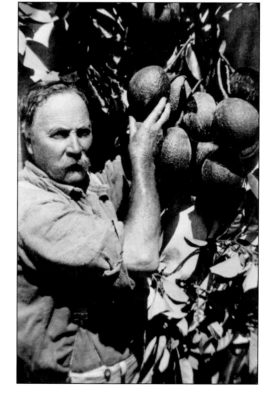

This 1928 photograph shows Sam Thompson, who was credited with planting the first avocado groves in Carlsbad in 1916, along Highland Drive, just east of the village. E. G. Litchfield was the second person to plant groves, in 1920. His acres were along the north shore of Agua Hedionda Lagoon. (Carlsbad History Room, Carlsbad City Library.)

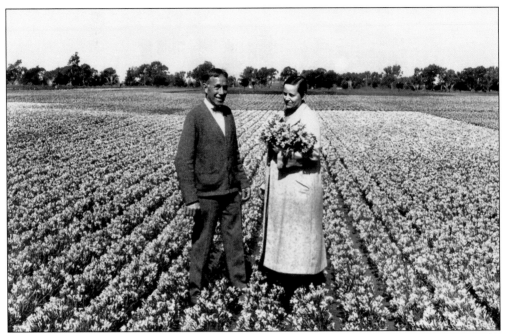

Luther Gage met and married Olive Carey in 1923 and made their home on Lincoln Avenue. The Gages had fields in Carlsbad as well as Oceanside. Although they had no children of their own, many neighborhood children near their home on Lincoln Avenue and Oak Street considered them Uncle Luther and Aunt Olive. (Marie Frazee Lawson.)

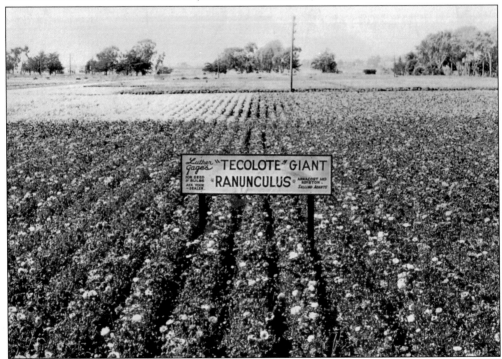

Luther Gage came to Carlsbad in 1921. With seeds he reportedly purchased from friends in England, he started the business "Luther Gage Tecolote Giant Ranunculus." (Marie Frazee Lawson.)

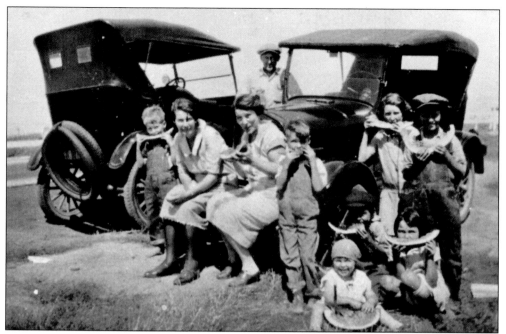

Taking a break for watermelon in 1926 are members of the Edwin Frazee family. Pictured from left to right are Elmer, Gladys, Ila, Harry, Howard, Clara, Betty, Ernie, Marjorie, and Edwin Frazee. (Carlsbad History Room, Carlsbad City Library.)

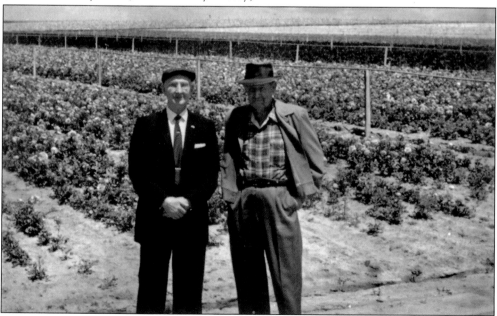

Earl Frazee, Edwin Frazee's uncle, started out as a foreman for Luther Gage in his flower business in the 1920s. But Edwin had become interested in the ranunculus flower when at 16 he planted his first crop. Both later worked in the business. Edwin later became at one point the only commercial grower of the ranunculus in the United States. Edwin's brother, Robert, a former state assemblyman and mayor, also worked in the business with him before retirement in 1993. Their father, Frank, is credited with bringing them into the business. (Marie Frazee Lawson.)

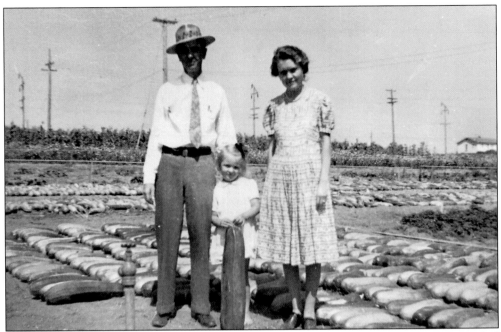

Charles Ledgerwood harvested zucchini to use in seed production. Three major truck lines picked up the produce in Carlsbad. Ledgerwood, a former Carlsbad mayor, continued to sell seeds from his store and home along Carlsbad Boulevard until he passed away in 1999. Pictured in 1940 are Charles Ledgerwood and Violet Ledgerwood with their daughter, Eldean Ledgerwood. (Carlsbad History Room, Carlsbad City Library.)

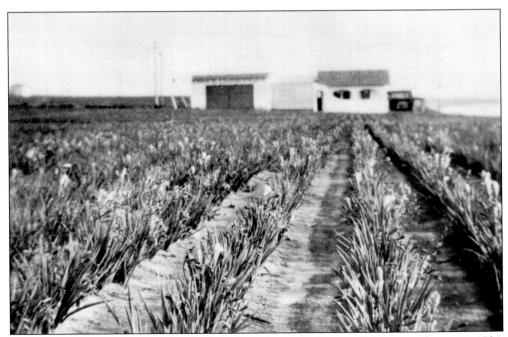

Freesias also grew in rows on Carlsbad Boulevard near Ledgerwood's home and store in 1934. (Carlsbad History Room, Carlsbad City Library.)

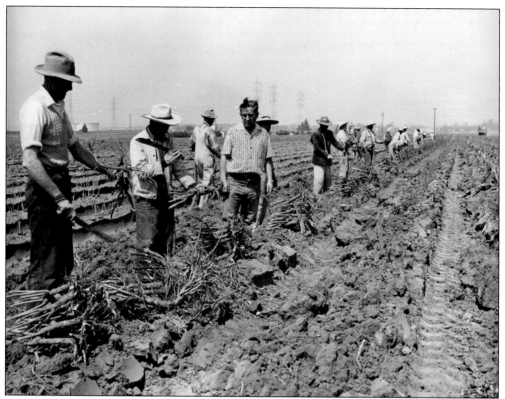

Workers would dig up the poinsettia root stock, which grew in the fields in Encinitas and Carlsbad, and take them to the Ecke Ranch in Encinitas, where they would box the roots up and ship them around the world. Workers in this 1950s photograph were thought to be in the fields above the San Diego Gas and Electric power plant. (Lizbeth Ecke.)

Until the 1960s, the Eckes were still growing poinsettia root stock in open fields on hundreds of acres in Encinitas and Carlsbad. But in the 1960s, the operation was moved into greenhouses, which changed the nature of the business dramatically. While they were growing near the power plant in this 1958 photograph, the fields were alive with the color red. (Lizbeth Ecke.)

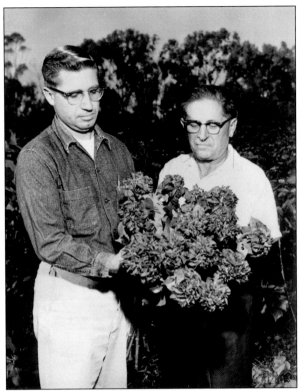

The Paul Ecke Sr. family began farming in the Los Angeles area in the early 1900s. In 1923, he moved to North County and was on the road much of the year promoting the poinsettias, which became synonymous with the Christmas holiday. Paul Ecke Jr. was born in 1925 and eventually took over operations of the business. Paul Ecke Sr. was inducted into the Society of American Florists Hall of Fame in 1970 and Paul Jr. in the early 1990s. Pictured are Paul Sr. and Paul Jr. in their greenhouses on Saxony Drive. (Lizbeth Ecke.)

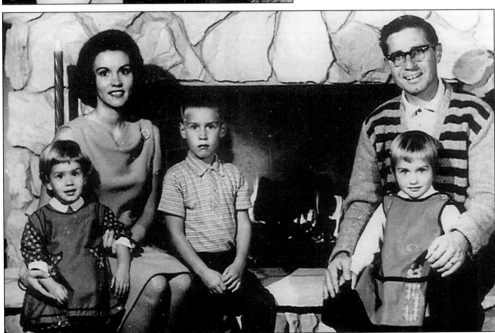

The Ecke family made their home on Saxony Drive in Encinitas, which was also the operation headquarters for the family business. Pictured are Elisabeth Kenney Ecke, Paul Ecke Jr., and their three children (from left to right), Sara, Paul Ecke III, and Lizbeth Ecke. Paul and Lizbeth have carried on the family business. (Lizbeth Ecke.)

Five

CARLSBAD IS ON THE MAP

Flowers were everywhere in Carlsbad in the late 1920s to the 1930s, and many driving through the area stopped to take pictures.

Many visitors to the area frequented what was then known as the "World-famous" Twin Inns restaurant.

The (California) Carlsbad Mineral Springs Hotel, also known as the Carlsbad Hotel and Mineral Springs, opened in 1930, bringing celebrities from Hollywood—those in the film industry and professional athletes as well—to town to enjoy the mineral springs and what the town had to offer.

Carlsbad became a resort destination or at least a stopover on the way to Agua Caliente in Tijuana and, later, the track in Del Mar.

The Great Depression took its toll on tourism in the area and on California in general. The Carlsbad Hotel and Mineral Springs was bought by Oliver M. Morris in 1939, and the wells were filled in. The name of the hotel was changed to Carlsbad Hotel by the Sea.

However, around the same time, in 1937, actor Leo Carrillo purchased the former Los Kiotes ranch and soon renovated and added to the ranch, located in the hills southeast of the Agua Hedionda Lagoon. Carrillo began hosting many of his friends from Hollywood.

Bing Crosby, who had a home in nearby Rancho Santa Fe, and other investors formed a company called Carlsbad Properties in 1944 along with the Casey family. They purchased the Cohn Estate and developed it into the Royal Palms motel and Sea Side Café, which later became Fidel's Norte. At one time, the Royal Palms had a wedding chapel.

In the 1930s, the Davis Military Academy also moved to Carlsbad from Pacific Beach, changing its name to the Army and Navy Academy. The addition of the academy added to the diversity of the unique coastal town.

Despite the economic hardships of the decade, the once sleepy little town of Carlsbad was on the map.

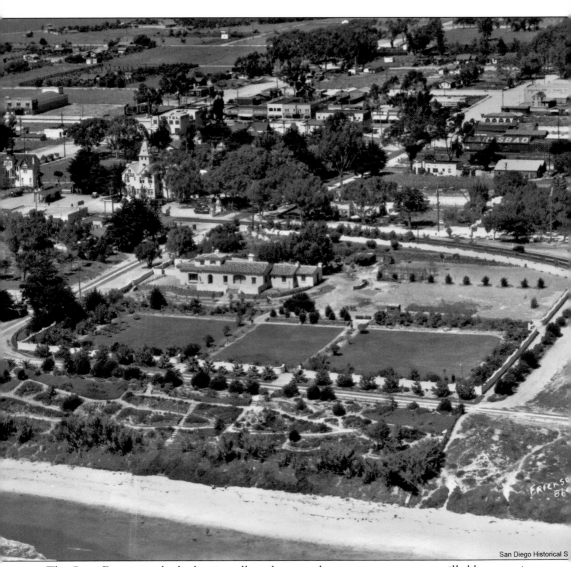

San Diego Historical S

The Great Depression had taken its toll on the town, but many growers were still able to survive. Slowly the avocado groves were giving way to flowers fields. Once called the Home of the Avocado, Carlsbad was becoming the Flower Capital. The road through town had been replaced with Highway 101 in 1928, which resulted in a decrease in traffic and business along First Street in the old part of town, now renamed State Street. However, the change brought traffic through the Twin Inns restaurant, seen in the photograph along with David D. Wadsworth's house. A year after this photograph was taken in 1932, 10 of the coastal acres were designated as a state recreational park. (San Diego Historical Society.)

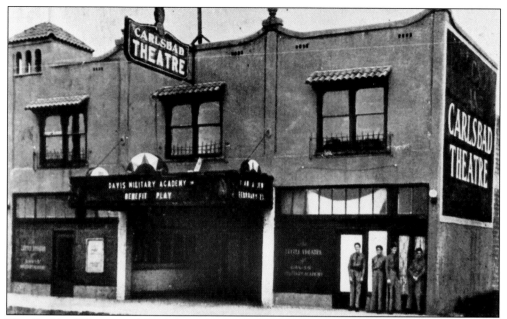

The Carlsbad Theatre celebrated its grand opening on February 8, 1927, with a showing of the film *It* starring Clara Bow. A. J. Clark was the developer and manager and hosted the ceremonies. The theater featured a full stage, fly gallery, orchestra pit, pipe organ, and flyable movie screen. The original cost was $40,000. Pictured are four Davis Military (before it was the Army and Navy Academy) cadets in front. (Carlsbad History Room, Carlsbad City Library.)

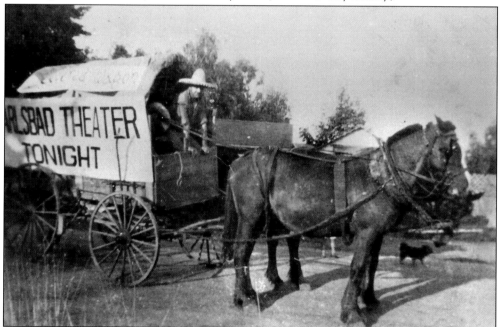

The Carlsbad Theater came up with creative ways to advertise their new productions. The theater changed names several times over the years, but it is still operating and is home to a strong community of supporters of the arts in Carlsbad. (Carlsbad History Room, Carlsbad City Library.)

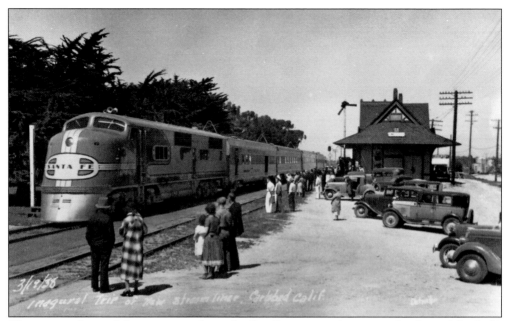

The inaugural trip of the new streamliner, the *San Diegan*, was documented to be on March 19, 1938. The 126-mile route from Los Angeles to San Diego was a popular one bringing many to Carlsbad, who often dined at the Twin Inns restaurant or stayed at the nearby Carlsbad Mineral Springs Hotel, which changed hands a year later, in 1939. (Carlsbad History Room, Carlsbad City Library.)

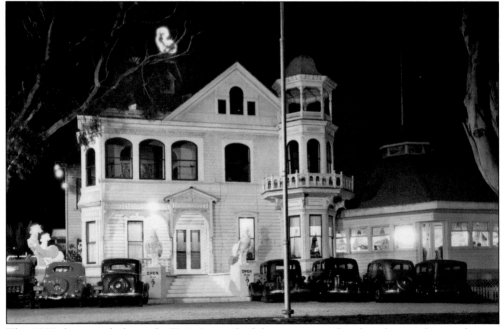

This 1928 photograph shows the Twin Inns, which became a popular place for travelers on the way to or from Los Angeles to stop in for the "famous" chicken dinners. It was purchased in 1919 by Eddie and Neva Kentner, who remodeled it and added a round dining room in 1918. The family, including five children, lived in the upstairs rooms. (San Diego Historical Society.)

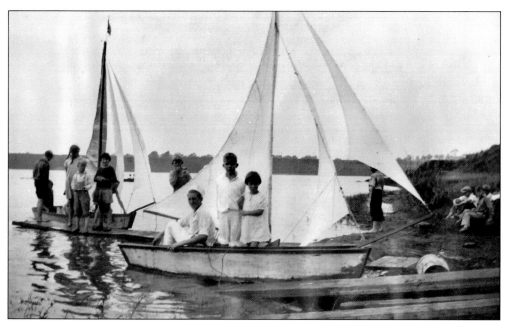

Sailing on the Buena Vista Lagoon was allowed in 1930, before it became a protected state ecological reserve. The mouth of the lagoon was once open to the ocean, so the water was brackish. Pictured is five-year-old Pat McClellan Baldwin sailing on the Buena Vista Lagoon with Loynal Wilson and Pat's brother, Jerry McClellan, who was nine years old at the time. (Pat McClellan Baldwin.)

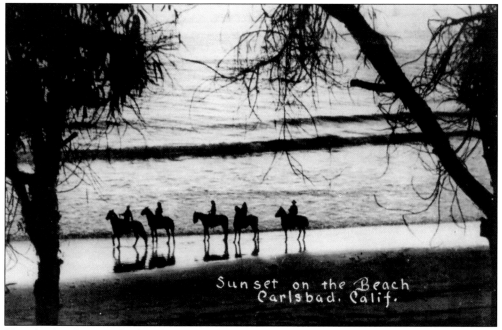

Horseback riding on the beaches in Carlsbad was a common activity in the 1940s and 1950s. With the many early ranches still operating in the back-country part of Carlsbad, the beach was easily accessible by trail. The back of the postcard simply reads, "Horseback Riding in Carlsbad." (Carlsbad History Room, Carlsbad City Library.)

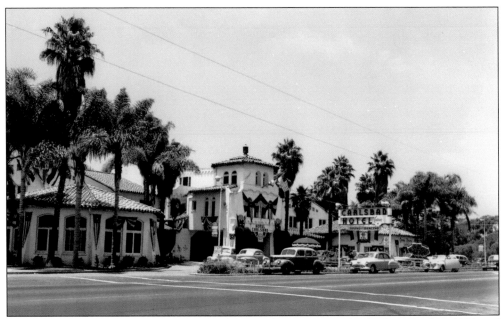

This 1949 photograph shows the Carlsbad Mineral Springs Hotel, which opened in 1930 and struggled during the late 1930s before changing hands in 1939. It was always popular with the Hollywood set. The hotel became the site of the dinner for the annual Bing Crosby golf tournament at Rancho Santa Fe Country Club. In 1944, Crosby, who had a house nearby in Rancho Santa Fe, formed a company called Carlsbad Properties to invest in property around the area. (San Diego Historical Society.)

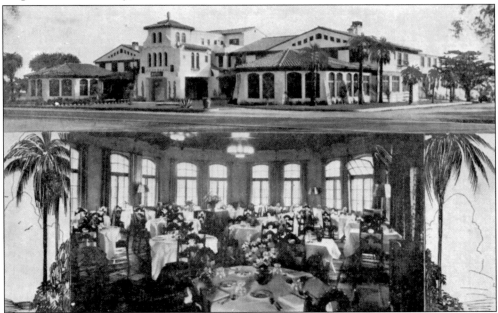

The Carlsbad Hotel and Mineral Springs was world famous for providing health and fitness amenities to guests. An advertisement for the resort read, "A Health Resort and Watering Place." It was touted as a hotel and clinic, with healing waters. In this 1930s postcard, the elegant dining room of the hotel is shown in the lower half. (Jack Greelis.)

The Carlsbad Mineral Springs Hotel property, by this time in the 1940s renamed the Carlsbad Hotel by the Sea, extended to the beach, where guests enjoyed private beach access with complete hotel services and amenities. (Jack Greelis.)

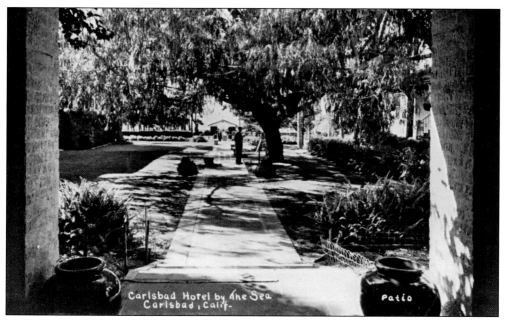

Carlsbad Hotel by the Sea
Carlsbad, Calif.

Patio

In the courtyard of the Carlsbad Hotel by the Sea was a legendary tree referred to as the "World Famous Weeping Eucalyptus Tree at Carlsbad Hotel by the Sea." The legend centers on a love story between two early Spanish settlers. When Don Carlos Fernando Osuna died at sea, Rosito, who often awaited his return under the tree, eventually died of a broken heart. Upon her death, the tree limbs began to bow and branches drooped. Visitors would come to see the unusual growth of the tree. (Johnny and Janet McKaig.)

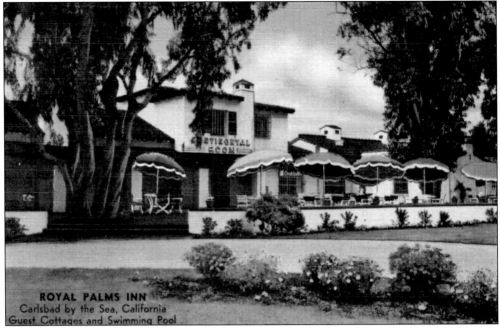

This postcard shows the Royal Palms Hotel, the former estate of Albert Cohn, a wealthy grocer from the Los Angeles area who made it his home in 1927. Eventually, after Cohn's death, Bing Crosby and other investors purchased the home and developed it into the Royal Palms motel and Sea Side Café, which later became Fidel's Norte. At one time, the Royal Palms had a wedding chapel. (Jack Greelis.)

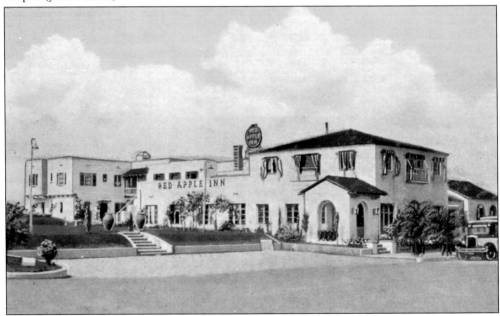

Built in the 1920s, the Red Apple Inn on Carlsbad Boulevard was a popular place to dine, with unique apple and avocado dishes on the menu. However, the inn and restaurant did not survive the Depression, and eventually the building was purchased in 1936 for use by the Army and Navy Academy; it still stands today. (Jack Greelis.)

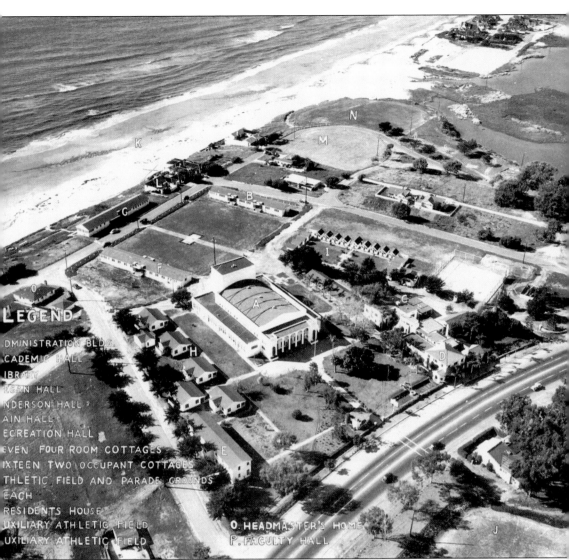

LEGEND

DMINISTRATION BLDG.
CADEMIC HALL
IBRARY
EGAN HALL
NDERSON HALL
AIN HALL
ECREATION HALL
EVEN FOUR ROOM COTTAGES
IXTEEN TWO OCCUPANT COTTAGES
THLETIC FIELD AND PARADE GROUNDS
EACH
RESIDENTS HOUSE
UXILIARY ATHLETIC FIELD
UXILIARY ATHLETIC FIELD
O. HEADMASTER'S HOME
P. FACULTY HALL

The Army and Navy Academy was started in 1910 by Col. Thomas A. Davis and his brother Maj. John Lynch Davis and was located in Pacific Beach, where it was called the Davis Academy. In 1936, the academy relocated to Carlsbad after economic conditions no longer made it possible to operate in Pacific Beach. It was initially located in the former Red Apple Inn and gradually expanded into the space it occupies today. This was made possible as a result of assistance from A. C. Anderson and family, who owned the land adjacent to the Red Apple Inn as well as nearby Granville Park. Army and Navy was started as a private institution with the intent of instilling the importance of high standards and values to young men. The ideals are similar in principle to military institutions; however, there is no direct affiliation with the U.S. military. This photograph was taken in the 1940s. The Army and Navy Academy is still going strong today as a service academy preparing students from middle school through high school for college. (Army and Navy Academy.)

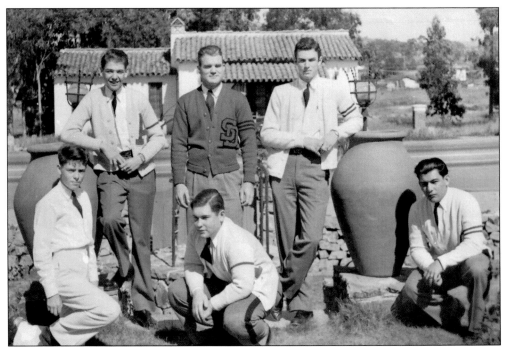

After relocating to Carlsbad in the 1930s, many of the students were still wearing letterman sweaters from the Pacific Beach facility, named the Davis Academy, indicating they are likely upperclassmen who started in Pacific Beach. (Army and Navy Academy.)

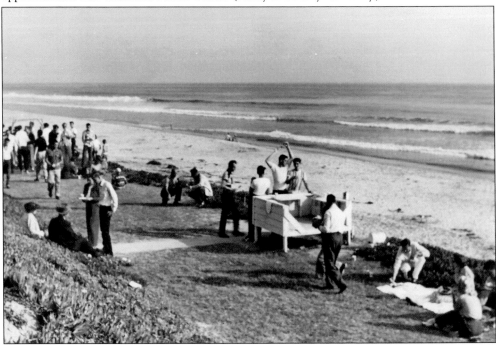

Student and family events have long been a tradition at Army and Navy, along with alumni events. This late-1940s photograph shows a gathering of students with families at the beach in front of the Army and Navy Academy. (Army and Navy Academy.)

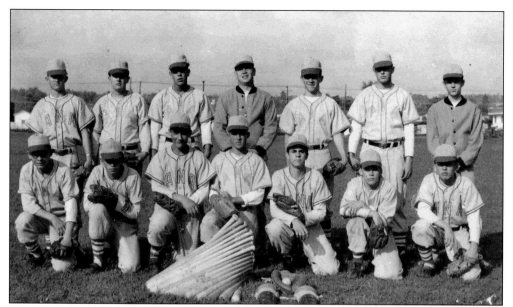

John Maffucci has had a long and highly accomplished career with Army and Navy, where he started as the football and baseball coach in 1957 and went on to become director of athletics. The athletic field at Army and Navy is named after him, and on October 28, 1994, the City of Carlsbad, at the request of Mayor Bud Lewis, declared that day as John Maffucci Day. The photograph shown is the 1957 Army and Navy baseball team with John as the head coach (shown in the middle). (Army and Navy Academy.)

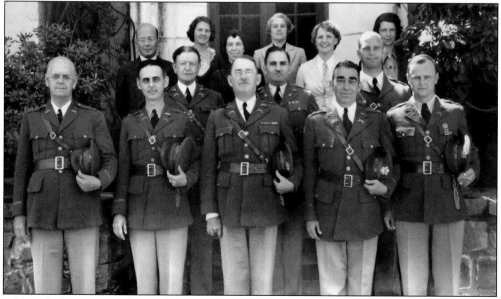

Although there was no direct affiliation with the U.S. military, the administrative officials wore uniforms. Four of the five men in the first row came up from Pacific Beach to Carlsbad in September 1936. This late-1930s photograph shows school staff and, from left to right in the first row, Col. Samuel Warfield Peterson; Col. W. C. Atkinson (a long-running president); Col. Thomas A. Davis (school president at the time); Maj. John Lynch Davis, Thomas's brother; and Capt. Earle T. Massey. Behind Atkinson is Virginia Powell Atkinson. (Army and Navy Academy.)

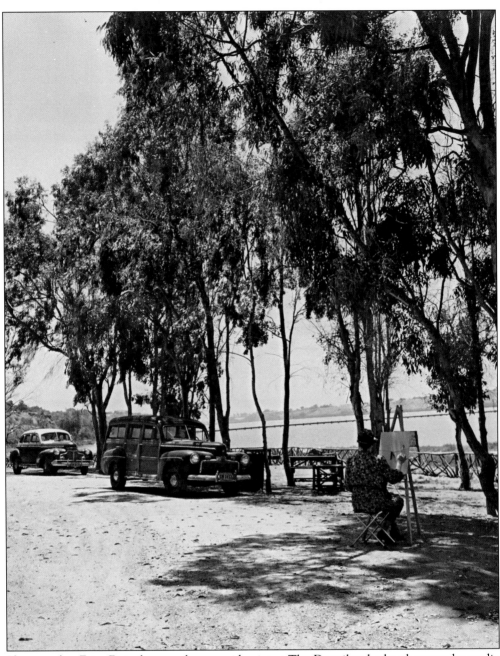

Photographer Ester Detwiler was also an avid painter. The Detwilers had a photography studio in the village for many years. She often painted alongside the Buena Vista Lagoon. In this late-1940s photograph, Detwiler is thought to be in Hosp Grove, looking northwest toward the ocean. Ester's daughter, Janet, married Johnny McKaig, a volunteer fireman and longtime local barber who had a shop on State Street for many years and was involved in the community. At one time, camping was allowed in the grove. (Johnny and Janet McKaig.)

Local resident Maxton Brown Jr. was an avid bird watcher. After he died while flying over North Africa during World War II, Carlsbad dedicated a popular bird-watching area in his honor for viewing a variety of birds on the southern bank of the Buena Vista Lagoon. A plaque still stands in the park off Laguna Drive. The photograph is of Lt. Maxton Brown Jr. at his sister's home in Denver, Colorado, taken just before he went overseas in 1942. (Carlsbad History Room, Carlsbad City Library.)

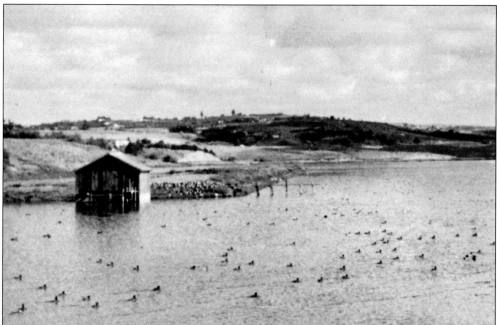

The "boat house" on the Buena Vista Lagoon was visible for years to motorists passing through the area. It was built in 1940 by Robert Baird and Kenyon Keith. Boating was allowed on the lagoon until a weir was added to the mouth of the lagoon and the lagoon became a wildlife sanctuary protected by the state. (Carlsbad History Room, Carlsbad City Library.)

Fraser's Dam, later called Lake Calavera, is located in the northeastern portion of the city and was built in the early 1940s. It provided Carlsbad with drinking water until Colorado water was brought in. Above the lake, a dormant volcano, called Mount Calavera, can still be seen. (Jeannie Sprague-Bentley.)

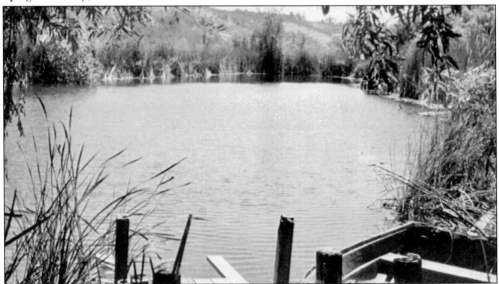

An artesian pond, a source of water dating back to the Native Americans, still exists on the La Rinconada de Buena Vista portion of the original Rancho Agua Hedionda property in the Buena Vista Creek valley. Called Marron Gorge, it was a source of water for early settlers and Carlsbad's first residents. (Melvin Sweet.)

El Salto Falls was once a popular place for swimming and diving, as this 1939 photograph shows. However, the depth was partially filled in to deter diving. Buena Vista Creek runs through the falls on the way to the ocean. According to an article in the *San Diego Union* in 2004, Native Americans discovered the falls 9,000 years ago; the falls are considered sacred. Another waterfall, called Three Falls, can be found on the southern border of Carlsbad in La Costa, in Box Canyon. (Walt Hansen.)

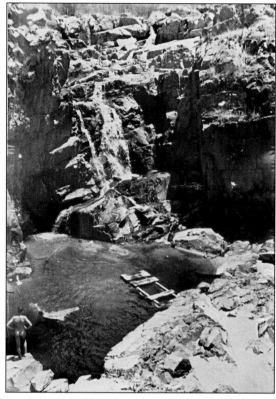

Originally home to the family of Silvestre Marrón, the L-shaped adobe, as it is known, went through a complete expansion and restoration in 1949 by Fred Hayes. The Marrón adobe still stands in the canyon near the Buena Vista Creek. (Shelley Hayes Caron.)

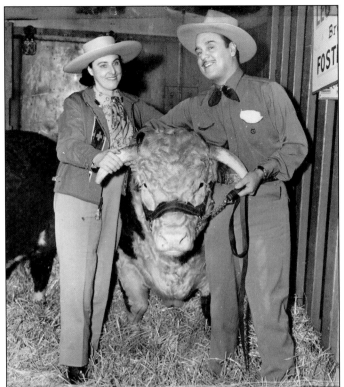

This 1940s photograph shows Leo Carrillo and his wife, Deedie, taking possession of a champion Hereford bull in Los Angeles. Leo purchased at least two champion bulls called Columbian Red Tops from Foster Farms. Leo and Deedie were married in 1916. (Leo Carrillo Ranch.)

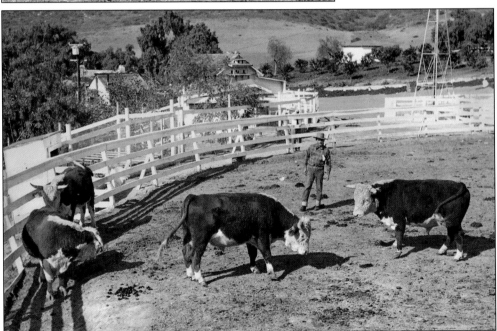

After purchasing the Rancho Agua Hedionda property of Matthew Kelly, known as Los Kiotes, in 1937 or 1938, Carrillo and his contractor, Cruz Mendoza, spent three years building the ranch, which he renamed Rancho de Los Quiotes. Pictured is a round-up of cattle on the ranch. Leo is shown in the center of the photograph. (Leo Carrillo Ranch.)

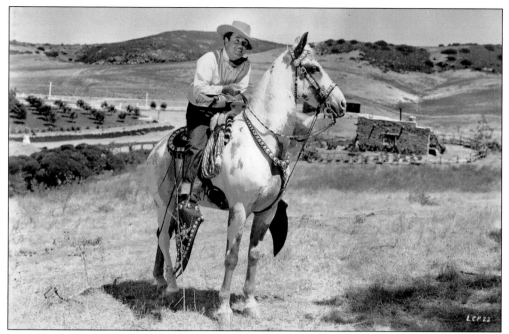

Leo Carrillo was considered an accomplished horseman and was a founding member of an elite Santa Barbara equestrian group called the Rancheros Vistadores. Carrillo is pictured in 1942 on his horse SuiSan at the ranch. SuiSan was a pinto and a talented parade horse that was good with crowds. (Leo Carrillo Ranch.)

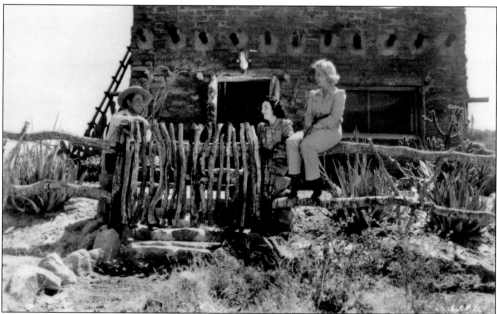

Leo and Deedie adopted Marie Antoinette, who was affectionately known as Tony. Leo built the house for Deedie primarily for her to use as a retreat and for her crafts, such as pottery and Native American art. The house also served as a guest house for Hollywood celebrities such as Clark Gable and Carol Lombard, who spent their honeymoon there. Pictured in the late 1930s are Leo, his wife, Deedie, and daughter Tony at Deedie's house. (Leo Carrillo Ranch.)

The Lambs Club was one of many Hollywood groups that Leo Carrillo hosted at his ranch. In this 1949 photograph, Leo is pictured on horseback at Los Quiotes surrounded by a group of men in T-shirts that read "Lambs Wash 49." (Leo Carrillo Ranch.)

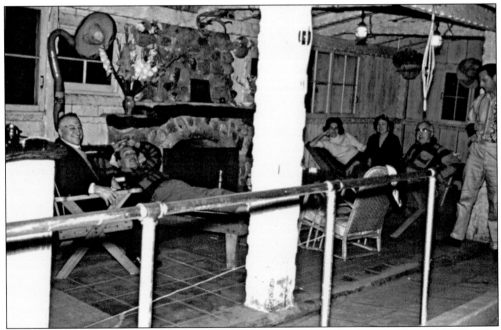

Leo often entertained and is pictured here with guests in the pool cabana in the mid-1950s. The guests are unidentified, but the gentleman on the left appears to be well-known entertainer Danny Thomas, who also founded St. Jude's Hospital in Memphis, Tennessee. Thomas was a frequent guest at the ranch along with Clark Gable and Carol Lombard. (Leo Carrillo Ranch.)

Six

CARLSBAD COMES OF AGE

After the Depression, the town rebounded, and many of the farmers were able to remain in business. During World War II, many in the village were involved in the war effort.

Postwar brought the servicemen home, and quite a few of them who were new to the community stayed. The baby boom generation desired the suburban lifestyle with "patio living," as promoted by the chamber of commerce.

The streets changed from numbers to names in 1947, and the town continued to grow.

In the fall of 1951, the chamber of commerce, which acted in the interests of the community before incorporation, called a meeting of civic leaders to discuss the possibility of incorporation and finding a secure source of water.

Residents had been talking about the annexation to Oceanside of a strip of coastal land along the shores from the Buena Vista Lagoon to the Agua Hedionda Lagoon.

However, the initiative failed in a tie vote, 45-45, in the spring of 1952. A couple of months later, residents voted on incorporation. On June 25, 1952, newspaper headlines from the *Daily Blade-Tribune* declared that Carlsbad was to incorporate by "a 781 to 714 Vote."

By the time of incorporation, in 1952, Carlsbad had almost 7,000 residents. A page from the *Carlsbad Journal* shows then-mayor Dewey McClellan updating an old sign posted at the entrance to the city, which had the city's population still at 4,383.

With the rapid growth came growing pains. And one of the biggest issues was the need to find a secure source of water.

Carlsbad had to secure city officials, and in July 1952, the new city held its "inaugural rites" and installed new officers. Two years later, water was brought down from the Colorado River.

The headlines of the *Carlsbad Journal* on June, 24, 1954, proclaimed "Colorado Water Now Flows Into Carlsbad." The long-awaited day gave city officials a reason to celebrate. Shortly thereafter, they began to work on building a city.

New fire and police departments were planned, roads and schools were expanded, and parks were built as the community rallied to build their small town into a city.

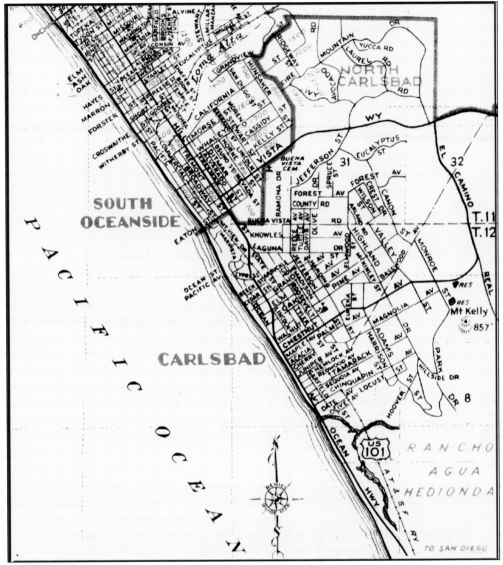

During World War II, many in the village were involved in the war effort. Many buildings were used for the war effort, and goods and services were rationed. Albert Kreutzcamp, who had acres of bean fields in what is now La Costa, then called Green Valley, headed up an effort to gather stones on the nearby beaches for mills in the Southwest. Another unusual endeavor for the war effort brought many to work in the fields with a plant called guayule. Because of war with Japan, one of the largest sources of rubber for the United States, alternatives were sought. The guayule had a sap much like latex. About 100 acres were planted near Agua Hedionda Lagoon. But the rubber it made never proved strong enough, and the fields were abandoned. During the war, the town was abuzz with activity. Just north of Oceanside was Camp Pendleton, which opened in 1942, and troops marched from Camp Elliot through Carlsbad on their way to the new base in 1943. Postwar brought the servicemen home, and many stayed. And the postwar baby boom followed. This map shows the names of the streets after they were changed from numbers to names in 1947. (Historic Map Works, LLC.)

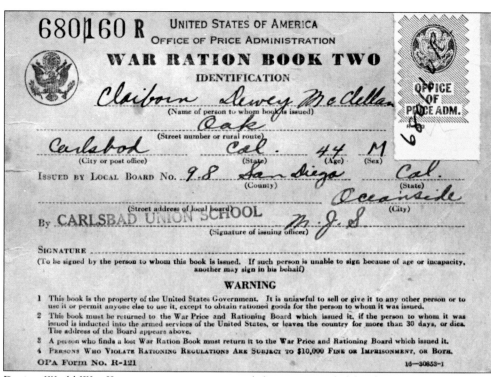

During World War II, many items were rationed that were needed for the war effort, including food and clothing. The ration system was a way to control the flow of materials into the war effort. Citizens were given a certain number of stamps each month for a particular item that needed to be turned over to the merchant in order to buy certain items. This war ration card was from Dewey McClellan, who would later become Carlsbad's first mayor. (Pat McClellan Baldwin.)

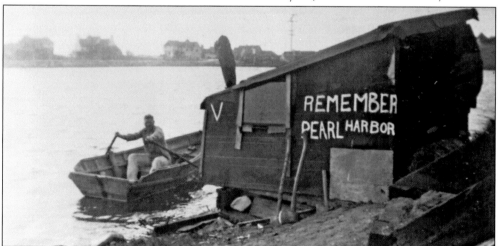

After the bombing of Pearl Harbor on December 7, 1941, the U.S. military instituted a policy of guarding railroad trestles on the west coast. This early-1942 photograph shows Berkeley West on duty guarding the railroad trestles at Buena Vista Lagoon (formerly known as Carlsbad Slough). Berkeley and Ole Sathrum were the two men responsible for guarding the trestles. They built the shack themselves. The upscale beach community of St. Malo is shown in the background. (Joyce Smith Collection.)

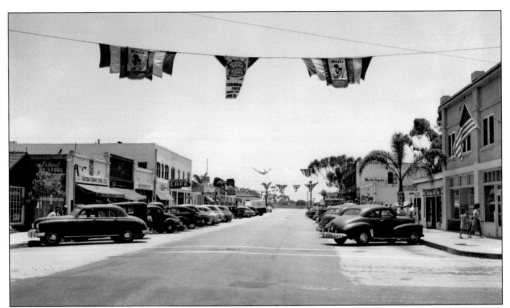

First Street, which later became State Street, was the main street used for travelers through Carlsbad. It took visitors right through town until U.S. Highway 101 was built in 1928. (San Diego Historical Society.)

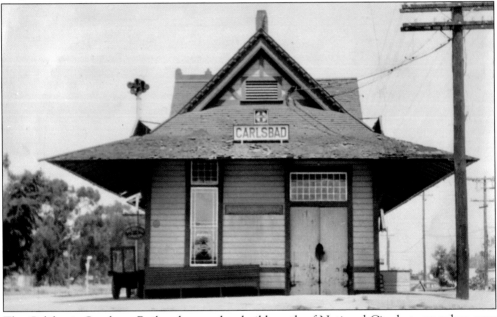

The California Southern Railroad wanted to build north of National City but was taken over by the Atchison, Topeka, and Santa Fe, which built a station in Carlsbad in 1887. The Surf Line began taking passengers north to Los Angeles beginning in 1888. Rail service stopped in 1959, almost 10 years after this 1948 photograph was taken. However, when the Coaster began service in the 1990s, Carlsbad once again had passenger service from the railroad. Although a new platform has been built, the existing Santa Fe Depot is still there and has been home to the Carlsbad Chamber of Commerce and now the Carlsbad Convention and Visitors Bureau. (San Diego Historical Society.)

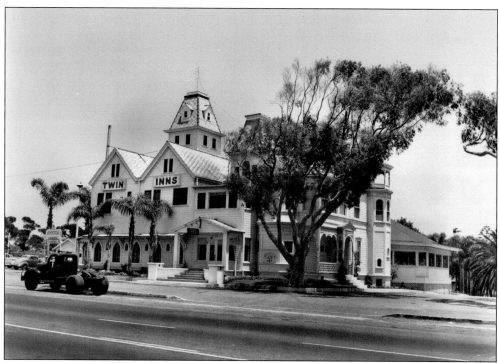

The Twin Inns was a popular stop for visitors traveling to or from Los Angeles on the way to the Del Mar Racetrack to have chicken dinner. During World War II, chicken was rationed, so the Kentners decided to go into the poultry business themselves. In 1943, they purchased land on Sunny Creek Road and called it Tootsie K Ranch. The photograph above was taken in the late 1940s. The photograph below was taken in the 1950s. (Both, Carlsbad History Room, Carlsbad City Library.)

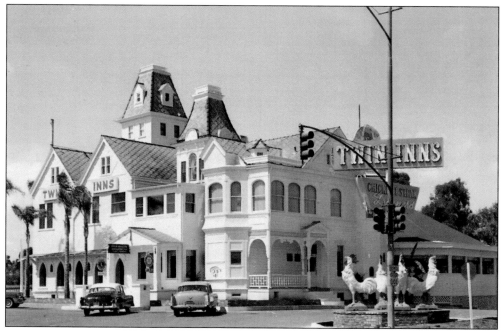

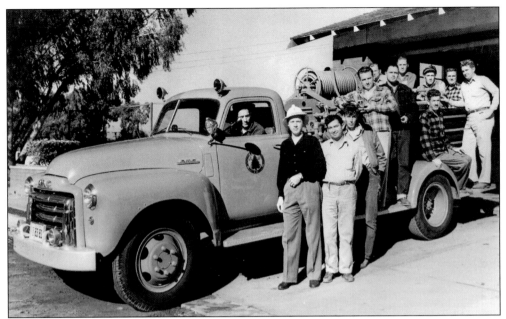

The California Division of Forestry (CDF) Fire Station was built in 1942. It was located at 2680 Highway 101, at the north end of the current town. In 1949, at the suggestion of state fireman Ted Walker, Carlsbad resident Huston Tucker recruited his brother Fred and 11 friends and formed the Carlsbad Volunteer Fire Department (CVFD). Here the volunteers stand with the state's fire engine outside the CDF station. (Carlsbad Firefighters Association.)

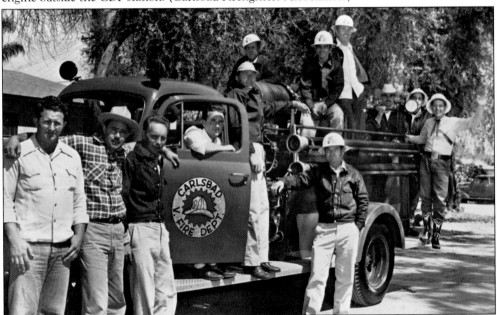

The Carlsbad Volunteer Fire Department was able to purchase their first fire engine in November 1951 from Dixon Ford in Oceanside for $2,350. The support of the community made this possible. Developer Bill Cannon lead the fund-raising efforts. The engine was housed in the garage of one of the volunteers, Bill Stromberg, on Roosevelt Street. Here the members of the CVFD stand with their fire engine. (Carlsbad Firefighters Association.)

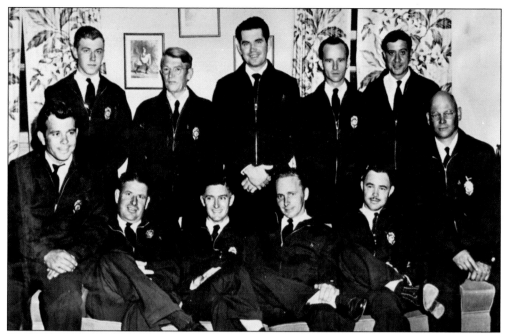

By October 1954, the Carlsbad Volunteer Fire Department had new uniforms. From left to right are (first row) Eddie Garcia, Art West, Jerry Standish, Bob Hardin, and Lou Haff; (second row) Warren Clark, L. V. Simmons, John McKaig, Charles Benner, Tony Vasileff, and Bill Stromberg. (Carlsbad Firefighters Association.)

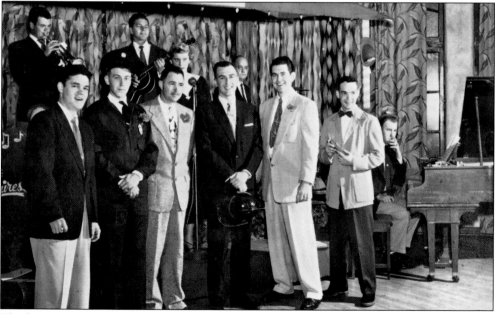

The first Fireman's Ball in 1954 was held at the Carlsbad Hotel by the Sea, where Johnny McKaig acted as the master of ceremonies. The Annual Fireman's Ball became an important fund-raising event for the purchase of equipment. Carlsbad volunteer firemen pictured here are, from left to right, (first row) Dick Harvey, Warren Clark, Lou Haff, Bill Taylor, and Johnny McKaig standing with members of the Lynn Bailey Band. (Johnny and Janet McKaig.)

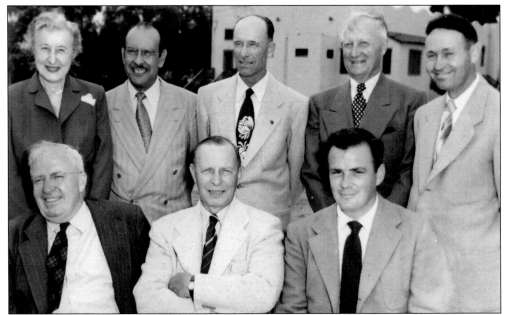

The first city officials were both elected and appointed on July 19, 1952. Pictured from left to right are (first row) city treasurer W. Roy Pace; city clerk Col. Edward Hagen; and city attorney T. Bruce Smith; (second row) council members Lena Sutton and Manuel Castorena; mayor C. D. "Dewey" McClellan; and council members George Grober and Ray Ede, who was Carlsbad's second mayor. (Pat and Bill Baldwin.)

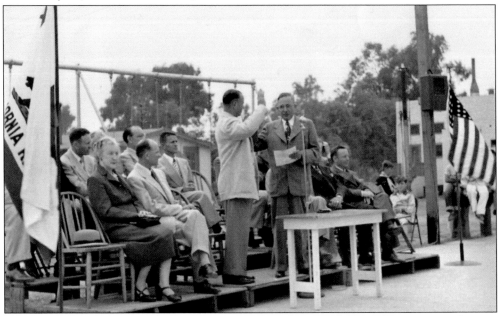

C. D. McClellan, or Dewey as he was known, was elected mayor of the newly incorporated city in 1952. The longtime community leader was associated with the development of the city of Carlsbad for 33 years prior to becoming mayor. He was president of the Oceanside-Carlsbad Realty Board, president of the chamber of commerce, and a school board trustee for the Carlsbad Union School District. (Pat and Bill Baldwin.)

Built in 1954, the city's first fire and police station opened in November. It was located on Pio Pico Drive, just east of the Oceanside to Carlsbad Freeway and north of Elm Avenue. Although the city funded most of the cost (approximately $18,500), it was built with the help of the community and the leadership of fire chief Bob Hardin. (Carlsbad Firefighters Association.)

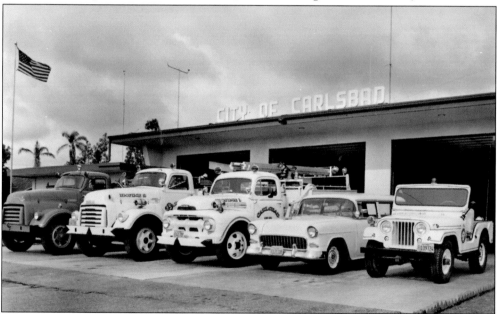

The Carlsbad Fire Department shared this station with the police, and later the city offices were added to the building on Pio Pico Drive. Parked in front of the fire station are the fire department vehicles: from left to right, a state Civil Defense GMC fire engine; Engine 2, a 1954 GMC pumper; Engine 1, the 1952 Ford pumper purchased by the volunteers; a station wagon used by the chief and occasionally as a backup ambulance; and a utility Jeep. (Carlsbad Firefighters Association.)

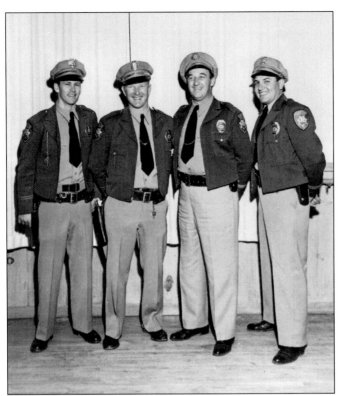

The first officers of Carlsbad Police Department in 1953 were, from left to right, Wallace Rossall, Samuel Walters, Urban ("Max") Palkowski, and Joe A. Castro. (Carlsbad Police Department.)

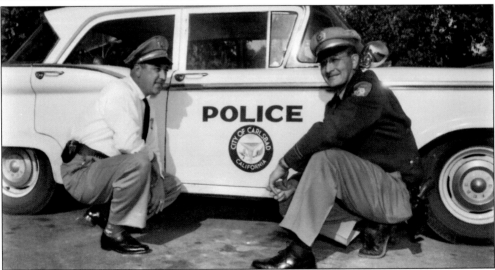

Floyd Hollowell was the first paid fireman, and police chief Max Palkowski was the first paid policeman. In this 1950 photograph, Palkowski (right) and Hollowell are shown with the city's first vehicle. Initially, police chief Palkowski had to use his own car until he got one from the city. According to information given out to new police officers when they receive a patch for their uniforms of the city seal, the seal is a triad, which represents the three famous qualities of the community. The sun and ocean represent the beach and environment, the city flower is the bird of paradise, and the cornucopia represents the richness of life in the community. (Carlsbad History Room, Carlsbad City Library.)

Police chief Max Palkowski submitted a monthly synopsis of police activity to the *Carlsbad Journal* newspaper in 1953. The report for July showed quite a bit of activity for the new city. (Carlsbad Police Department.)

Carlsbad Police Dept. Monthly Report

Following is the report of all police activity from the period of July 1, 1953, through July 31, 1953, inclusive.

ARRESTS

Intoxication	4
Drunk in auto	2
Disturbing the peace	3
Failure to provide for minor child	3
Possession of dangerous drugs	1
Total	**13**

ACCIDENTS

Non-injury	13
Injury	4
Fatals	2
Total	**19**

TRAFFIC CITATIONS ISSUED

(Speed and others)	125
Total	**125**

GENERAL CASES

Warrants served (outside)	6
Petit thefts	4
Juvenile cases processd	11
Child molestation	1
Indecent exposure	2
Lost property	1
Malicious mischief	1
Trespassing	1
Burglaries	1
Burglaries attempts	3
Automobiles impounded	3
Misc. complaints	47
Total	**81**

Respectfully submitted,
U. Max Palkowski
Chief of Police

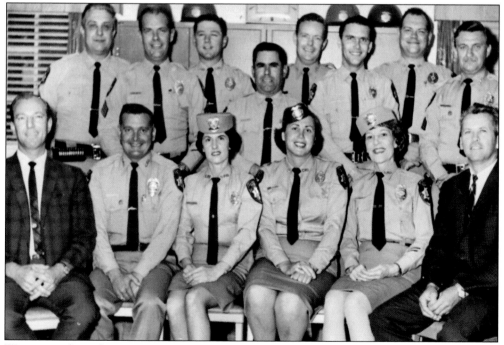

Women in the police reserves were common during and right after the war, but the numbers dwindled. This 1953 photograph shows the men and women police reserves, a program the Carlsbad Police Department still uses today. (Carlsbad History Room, Carlsbad City Library.)

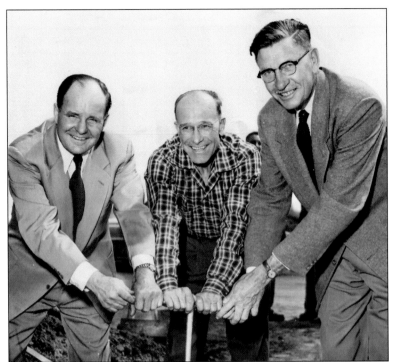

The headlines of the *Carlsbad Journal* on June 24, 1954, proclaimed, "Colorado Water Now Flows into Carlsbad." The long-awaited day gave city officials a reason to celebrate. Here Mayor Dewey McClellan (right) is officially "turning on the water" on Monday, June 21. (Pat and Bill Baldwin.)

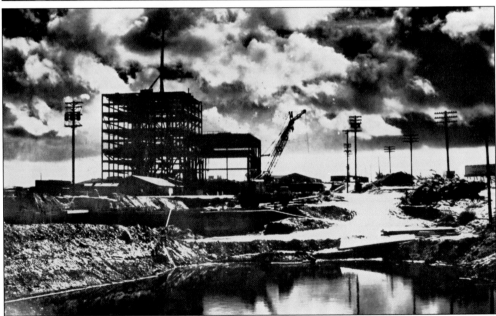

Construction of the power plant, now called the Encinas Power Station, began in January 1952 and was completed in November 1954. At the time of completion, it was San Diego Gas and Electric's largest fossil-fueled electric generating plant. Two additional generating units were added in 1976. Expansion plans came again in 2007 as well as the addition of a desalination plant on the property to turn saltwater into drinking water. Also located on the outer basin of the lagoon are marine life research and fish cultivation projects visible to those driving along Carlsbad Boulevard. (Carlsbad History Room, Carlsbad City Library.)

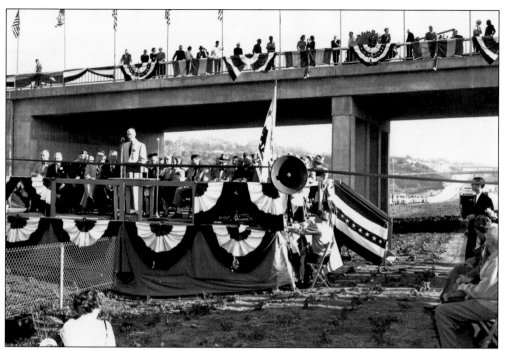

In 1953, the second stretch of the new Interstate 5 freeway was dedicated. The 10.7-mile section of the highway was constructed to run between Oceanside and Carlsbad. Later additional stretches were added and expanded. (Pat and Bill Baldwin.)

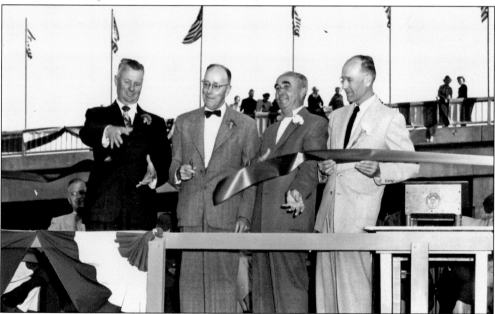

A ribbon-cutting ceremony was part of the festivities to celebrate the opening of the new Oceanside-Carlsbad section of the freeway. Later the widening of the freeway brought a realignment of Pio Pico Drive, where city hall had been, along with the first fire and police stations. Traffic on Highway 101, now Carlsbad Boulevard, dropped from 55,000 cars per day prior to the freeway opening to 7,000. Pictured are Dewey McClellan (far right) and city officials. (Pat and Bill Baldwin.)

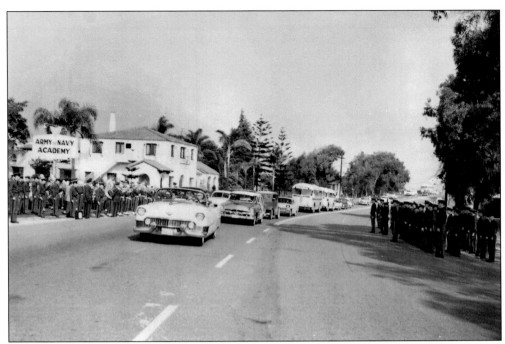

After the opening of the new Carlsbad High School in 1958, students paraded down Highway 101 from Oceanside to the new school, passing in front of the Army and Navy Academy. The event was re-created in 2008, on the school's 50th anniversary. Pictured here is the initial parade through town. (Carlsbad History Room, Carlsbad City Library.)

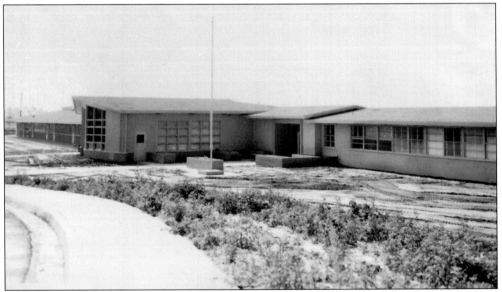

It didn't matter that the new Carlsbad High School had little landscaping when it first opened in 1958; the growth was to come along with the growth of Lancer pride. The school grew rapidly until almost 40 years later, when another high school was opened in the southern part of Carlsbad. La Costa Canyon High School, which opened in 1996, is actually part of the nearby San Dieguito Union High School District. In 2008, a third high school was approved for the northern part of the city. (Carlsbad History Room, Carlsbad City Library.)

Carlsbad High School's first Lancer Day Parade was held on Friday, November 13, 1959. The first Lancer Day court was Queen Judy Sousa and princesses Judy McCartney, Noel Larson, Vera Soto, and Margarita MacEachen. (Carlsbad History Room, Carlsbad City Library.)

Carlsbad High School's first graduation class boasted the now notorious Lancer pride. Many success stories have come out of the school and the athletics department, led for many years by Don Johnson. All the schools located within city limits are considered to be among the top schools in the nation, well above the national average. (Carlsbad History Room, Carlsbad City Library.)

The Oceanside-Carlsbad Sportsman Club worked to raise money for the dredging of a small boat harbor in Agua Hedionda Lagoon. The effort gained much publicity and excitement. Later, when San Diego Gas and Electric built a power plant on the shore, which opened in 1954, portions of the lagoon were dredged for a cooling water basin. Shortly after, San Diego Gas and Electric issued a statement in which they said that they felt a small boat harbor would not be compatible with the operation of the power plant. (Carlsbad History Room, Carlsbad City Library.)

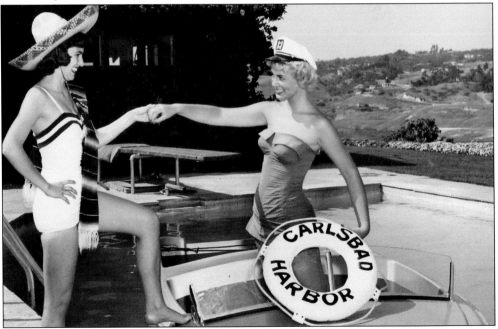

Betty Jo Whitmer (left) and Nancy Neilson pose for a 1954 publicity photograph for the Spring Holidays. Nancy was representing Carlsbad at the Camp Pendleton Queen Contest. The boat was floating in the swimming pool of Carlsbad residents Mr. and Mrs. Arnold Brilhart. The boat was a prize for the Spring Holidays contest. The photograph was used in the *Carlsbad Journal*. (Carlsbad History Room, Carlsbad City Library.)

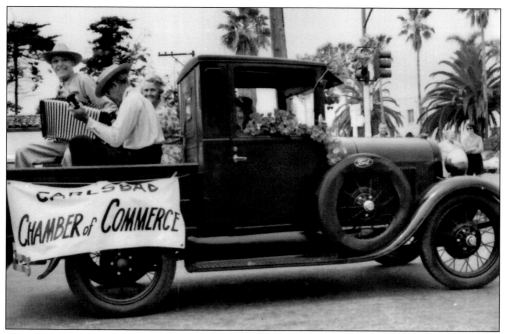

The chamber of commerce took over the coordination efforts of the Spring Holidays parade. This event helped bring the town together. The weeklong celebration ended with a dance at a nearby hotel. The parade often featured old cars, school bands, and floats. Both photographs on this page were taken in 1955. (Carlsbad History Room, Carlsbad City Library.)

The Garden Club, pictured at the Spring Holidays parade, was founded in 1931 as an outlet for the Woman's Club. According to members, it was founded during the Great Depression as a way for women to beautify their communities, protect the natural habitat, and bring awareness, as well as cultivate exciting friendships. (Carlsbad History Room, Carlsbad City Library.)

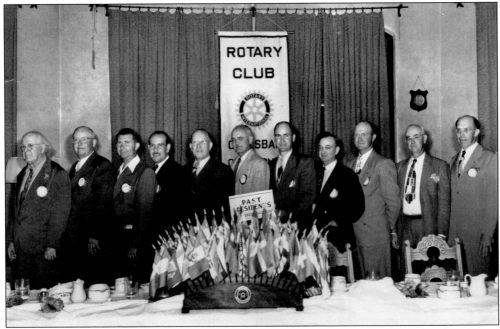

The Rotary Club was the club behind the Spring Holidays event; however, the chamber of commerce eventually took over the coordination of the weeklong celebration. The Rotary Club, which was chartered in 1939, was one of the first service clubs in Carlsbad. Pictured in the early 1950s are the club's past presidents. (Carlsbad History Room, Carlsbad City Library.)

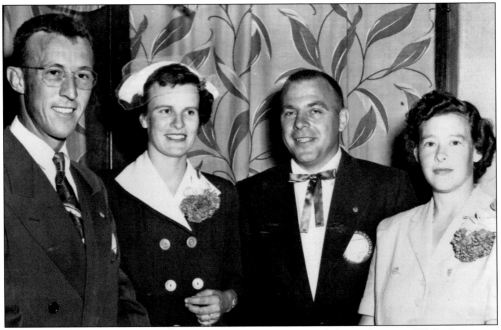

The Lions Club was another of the first community service clubs in the area. With the motto "We Serve," the club has provided community service and organized fund-raising events. Pictured in 1952 are, from left to right, outgoing president Lewis Chase, Pat Baldwin, incoming president Bill Baldwin, and Lewis's wife, Polly. (Pat and Bill Baldwin.)

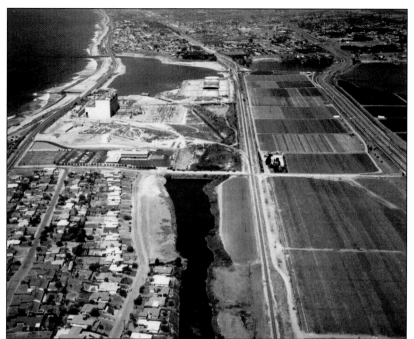

In the late 1960s, Carlsbad began to make the transition from agricultural land to suburban community. After incorporation, the once-county-maintained streets became city property, and the city came up with new and innovative ideas. Here a coupon put out by the Carlsbad Street Maintenance Department shows the city's diligence in keeping up with the pace of growth and the diverse terrain. The concept was brought to the city by Bill Baldwin, assistant city manager, who modeled it after a similar program in another city. (Bill and Pat Baldwin.)

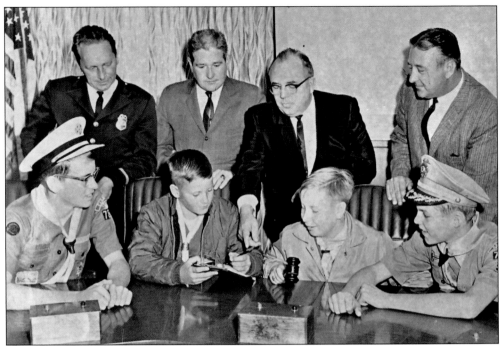

Boy Scouts are pictured in 1968 with, from left to right in the second row, the city's first fire chief, Bob Hardin; city manager John Mamaux; Mayor Carl Neiswender; and the city's first chief of police, Max Palkowski. Mamaux was instrumental in bringing Car Country Carlsbad and Plaza Camino Real to the city. (Carlsbad History Room, Carlsbad City Library.)

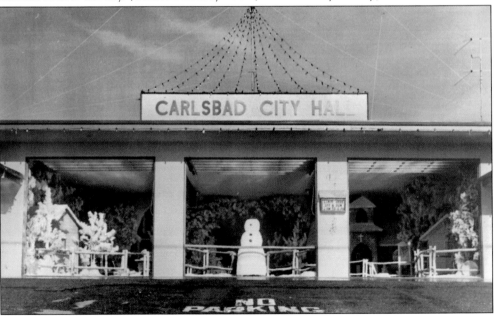

The Christmas Village display was put together by fire department personnel every year until the station had to move to make way for the widening of the freeway in the late 1960s. The display of lights could be seen by motorists passing by from the freeway and attracted thousands of visitors each year from 1954 to 1969. (Carlsbad Firefighters Association.)

The new city library opened in 1969 to much fanfare. Prior to its location on Elm Avenue, now Carlsbad Village Drive, the library was housed in several different buildings and moved several times. The library was named after librarian Georgina Cole, thanks to her "hard work and diligence" in making it happen. Now the city has three libraries. Dove Library, in south Carlsbad, opened in 1999 and the Library Learning Center in 2008. (Carlsbad History Room, Carlsbad City Library.)

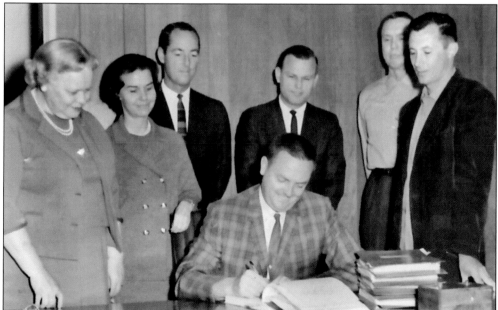

Library trustees signed the documents needed in 1968 for the building of the new library on Elm Avenue, now Carlsbad Village Drive. The new library was built shortly after the new city offices. Pictured from left to right are city librarian Georgina Cole and the trustees of the library: Dorothy Sheffler, Stuart Wilson, Jim Gaiser, and Mayor Bill Atkinson (seated). The two men at right are unidentified. (Carlsbad History Room, Carlsbad City Library.)

The fire department maintained a station log book for tracking both emergency and non-emergency activities. This page from the 1962 log book shows that firemen Bill Hill and Vern Coble were relieved at 0730 hours on August 20 by firemen Jack Osuna and Alex Wolenchuk. On this day, they responded to two medical emergencies and a kitchen stove that "blew up." (Carlsbad Firefighters Association.)

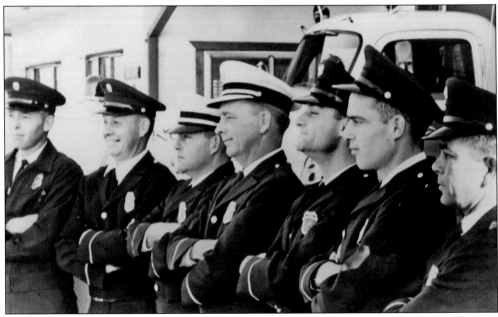

These full-time members of the fire department were assisted by the volunteer firemen on significant emergency incidents. The members of the Carlsbad Fire Department in 1962 were, from left to right, fireman Vern Coble, fireman Alex "Chuck" Wolenchuk, Capt. Jack Osuna, Chief Robert "Bob" Hardin, fireman Jerry Edwards, fireman Bill Hill, and fireman John "Eddie" Garcia. (Carlsbad Firefighters Association.)

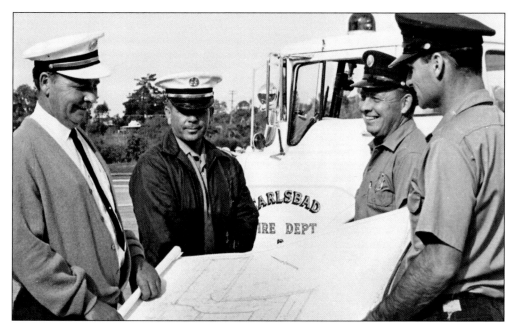

As a result of the widening of the freeway, the fire and police station as well as the city hall on Pio Pico Drive had to be demolished. The fire station was rebuilt at 1275 Elm Avenue. It opened in September 1968. Here, from left to right, fire chief Bob Hardin, Capt. Eddie Garcia, and firemen Alex Wolenchuk and Jerry Edwards view the building plans in early 1968. (Carlsbad Firefighters Association.)

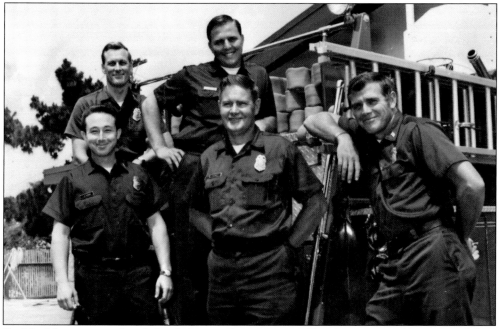

Carlsbad firemen standing behind the new fire station on Elm Avenue in 1969 are, from left to right, (first row) Lloyd Almand, Darrell Bennett, and Rich Walton; (second row) Ernie Bond and Dean Harrold. Lloyd left the department in 1972, Darrell retired in 1985, Rich retired in 2002, Ernie retired in 1987, and Dean passed away in 1990. (Carlsbad Firefighters Association.)

The original airport was an airstrip still used in the 1960s, despite a new airport farther south. Construction of the new Plaza Camino Real mall is underway, but most is out of sight to the left of this aerial image. The airstrip was closed in the late 1960s, around the time the mall opened. (Hayes-Marrón Collection.)

Named after Gerald McClellan, McClellan-Palomar Airport was built in 1958, and in 1973, the control tower was added. In 1977, an instrument landing system was added and approach lights were installed. The airport has grown and now has passenger service, prompting a need for expansion. This same terminal was used for years until a new one was built in 2008. (Jeannie Sprague-Bentley.)

Seven

FUN IN THE SUN

As the city grew, so did means of recreation. Although it had been around since the 1920s, surfing became the new craze in the 1950s and 1960s.

In the 1950s, a community effort to make Agua Hedionda Lagoon into a small boat harbor eventually ended, but Agua Hedionda Lagoon was still the place to be, attracting swimmers, boaters, and skiers, as well as those who loved to fish.

Carlsbad was where the action was inland as well.

At the world-famous Carlsbad Raceway, which opened in 1964, Friday night drag races were a hit, bringing top professional drag racers to town. The 1960s saw the sport of drag boat racing on the Agua Hedionda Lagoon take off as well.

The 1970s ushered in the beginning of the action sports era, and much of that action started in Carlsbad.

Long boards gave way to short boards, and surfing competitions grew. Many professional surfers, such as big wave riders Taylor Knox, David Barr, Scott Chandler, and Randy Laine, got their start on the beaches of Carlsbad. Around the same time, Kawasaki, based in Irvine, brought a prototype for a new "water motorcycle" to the lagoon, where hands-on testing led to the birth of a new sport on the shores in Carlsbad. Personal watercraft (PWC) pioneers, such as Rusty Sharman, raced in the first Jet Ski races on the lagoon, and action sports pioneer Randy Laine began jumping the waves at Tamarack Beach.

Motocross took off in the 1970s as well, and the U.S. Grand Prix came to the raceway. At the world's first skate park, built next door to the raceway, skateboarders popularized concrete surfing and skiing. Opened in March 1976, the Sparks Carlsbad Skate Park, called Mogul Maze, allowed skaters to simulate the ski mountain moguls and was an instant hit. The pioneer skaters at the park paved the way for future generations of skaters, such as local resident Tony Hawk, skate and snowboard medalist Shaun White (who grew up in Carlsbad), Ryan Gallant, and the new generation of extreme sports athletes. But it was short lived. Years later, in 2005, an effort to save the raceway and skate park ended in defeat. Now a new business park marks the memories below the surface. However, just over the hill, the La Costa resort was putting Carlsbad back on the map as a tourist destination, eventually drawing crowds to professional tennis and PGA golf events. The campground continued to provide a getaway, and Carlsbad continued to provide "Fun in the Sun."

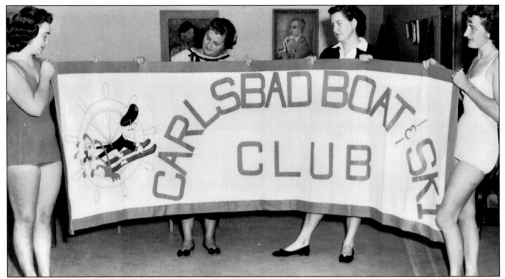

Once San Diego Gas and Electric built the power plant and dredged the Agua Hedionda Lagoon for a cooling basin, excitement over the many possibilities for recreation grew. Pictured in the 1950s are members of the new Carlsbad Boat and Ski Club. (Carlsbad History Room, Carlsbad City Library.)

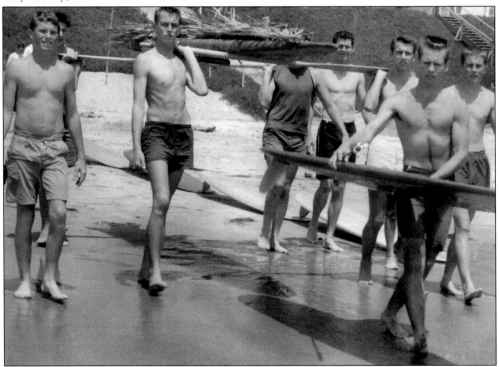

Surfing had its early origins in Hawaii before coming to the west coast of California. The sport was relatively new in the 1950s, when it became a craze. Pictured here are a group of surfers said to be sacrificing a damaged surfboard to the "surf gods" during a party at the home of Brian Weiner near Terramar. They are Greg Anderson, Bob Ness, Donald ?, Art Valentine, Mike Breen, and Hap Ness. (Carlsbad History Room, Carlsbad City Library.)

Boating and water skiing took off in the 1950s and 1960s. Names for the shore of Agua Hedionda varied over the years from Evan's Point, Fox's Landing, and Snug Harbor to Whitey's Landing, depending on the boat launch and who was in charge. (San Diego Historical Society.)

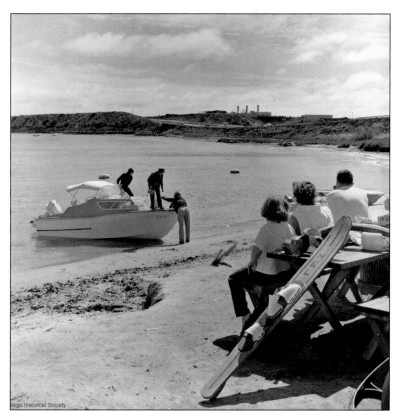

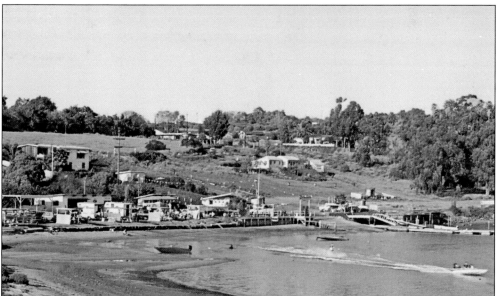

Early on, there was a push to make the Agua Hedionda Lagoon a small boat harbor "comparable to that of Newport Harbor." A seven-member harbor commission was even formed to explore the idea, until the owners of the new power plant rejected the idea. The train trestle and new freeway complicated matters, but the lagoon still developed as a popular spot for water sports, as seen in this 1960s postcard. (Jack Greelis.)

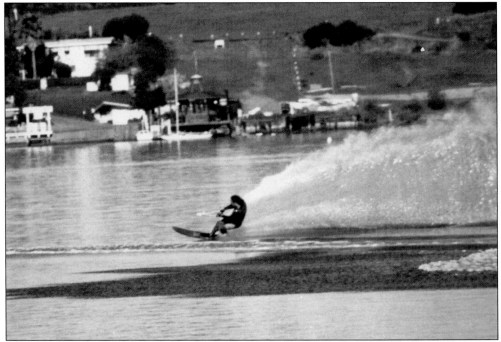

Although slalom skiing has been around since the 1920s, it became increasingly popular on the lagoon in the 1970s. Pictured is local Randy Laine on Agua Hedionda Lagoon. Laine was soon to become well known for his extreme athletic endeavors. (Randy Laine.)

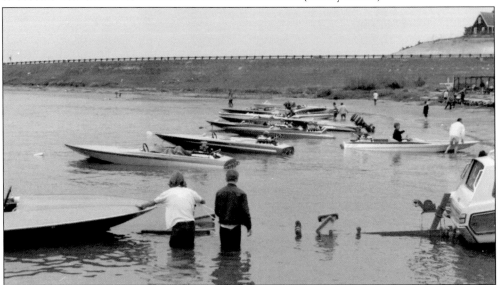

Flat-bottom boats became popular in the 1950s and 1960s. The Litchfield brothers were innovators of boats that could navigate the shallow waters. Drag races became popular, with the boats reaching speeds of 100 miles per hour. On weekends, Fox's Point or Landing, run by ex-navy chief John Fox, was at one time launching hundreds of boats a day. The popularity of the lagoon prompted the Carlsbad Police Department to buy their first boat to patrol the area, where Carlsbad police officer Harry Walton is credited for being the first to use flags during waterskiing in an attempt to reduce accidents. (Rusty Sharman.)

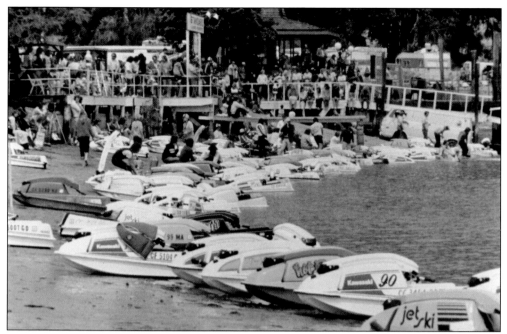

Kawasaki was experimenting with a new "water motorcycle," designed by Clayton Jacobsen II. Kawasaki brought their prototype to the lagoon, where they found Dave Sammons, Rusty Sharman, and other locals to test the new Jet Ski. The sport caught on, and the first Jet Ski race was held at Snug Harbor Ski Hut in 1978. (Rusty Sharman.)

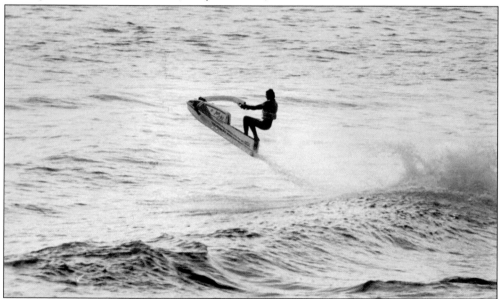

Meanwhile, in 1972, local Randy Laine took a Kawasaki 400cc Jet Ski under the train trestle and freeway overpass into the open ocean, where he began jumping the waves at Tamarack State Beach. A few years later, in 1979, he towed his brother Wes out into the waves. This eventually led Laine to be the first to develop "tow-in-surfing." In 2001, he set a world record for the biggest wave ever ridden on a Jet Ski, a Yamaha Super Jet, when he conquered a 72-foot wave at Cortes Bank. (Randy Laine.)

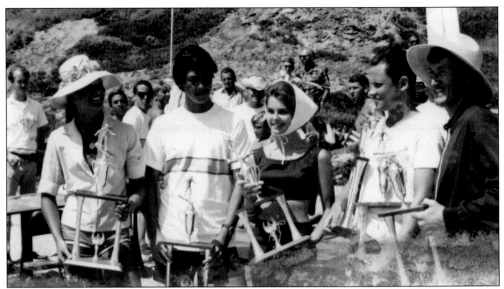

Tamarack Beach was the site of many surf contests. Well-known surfers receiving their trophies in the 1960s were, from left to right, Joyce Hoffman, David Nuuhiwa, Danielle Corn, Corky Carroll, and Rusty Miller. Joyce went on to be the first female lifeguard for the city of Del Mar in 1971. (California Surf Museum.)

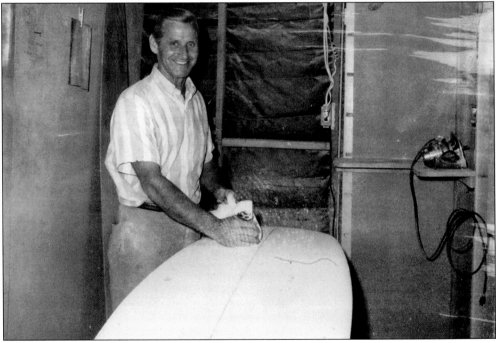

This 1966 photograph shows Frank Hecklinger, a waterman who was stationed in Hawaii during the war and designed and built his first surfboard shortly after. In 1947, he settled in Oceanside, opened a shop in Carlsbad, and sold surfboards by Heck. He eventually became one of the best-known shapers and opened Tamarack Boards. His sons, Ron and Bob, took up the sport, and Bob surfed for Don Hansen's team and the Windansea Surf Club. Frank went out of the shaping business when his shop was broken into. (Jeff Warner, Legends Surf.)

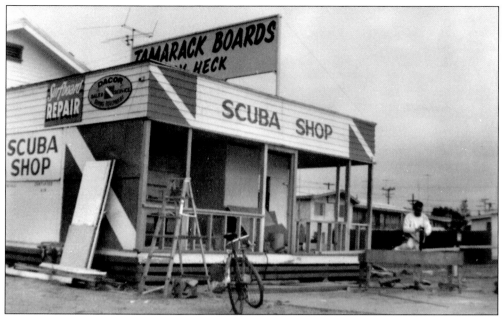

Tamarack Boards was one of the few places where surfers could buy a new surfboard in the late 1960s. Frank Hecklinger had been designing boards since the 1940s and by 1964 had his own shop on Elm Avenue, now Carlsbad Village Drive. In 1968, he opened a new shop on Highway 101, Carlsbad Boulevard, where Dini's restaurant is now located. His shops also sold scuba gear. (Above, Legends Surf; below, California Surf Museum.)

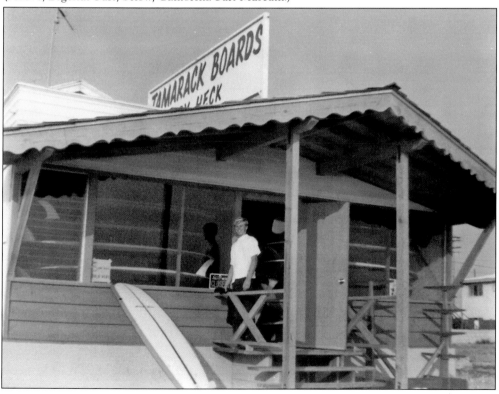

Professional surfer Barbie Baron, who became one of the top five women in the world in the 1970s, opened Offshore Surf Shop when she was only 17 with money she had won in contests. Originally sharing a building with the popular hangout Novak's Burgers, across from Tamarack State Beach, it moved several times before the final move in 1978 to its current location, just north of Pine Avenue. (Barbie Baron.)

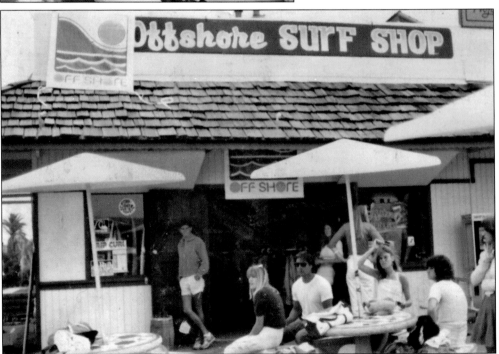

Offshore Surf Shop became an immediate hangout for local surfers. Just north of Pine Street, the break in front of the shop was affectionately called Offshore. The day this photograph was taken, local Joey Buran was running the first surf contest for Offshore Surf Shop in 1978. (Barbie Baron.)

Local surfer Randy Laine (right), who surfed professionally before becoming an action sports pioneer, and local surfer Jimmy Schneider (left) are pictured at Tamarack Beach before there was a paved parking lot and a seawall. Before surfing the big waves, Randy Laine surfed the waves here at Tamarack State Beach in the 1970s. (Both, Randy Laine.)

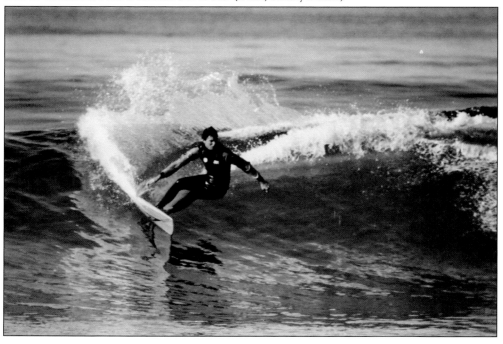

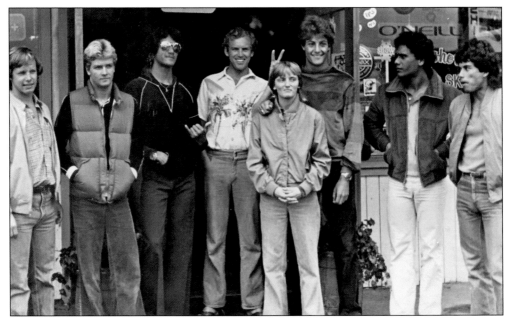

Many professional surfers have gotten their start on the beaches of Carlsbad. In an article in the *San Diego Union* dated December 1982, Mike Baron, brother of Offshore Surf Shop owner Barbie Baron, is quoted as saying, "The glamour's up in Newport and Huntington, but the surfing's down here." Hanging out in front of Offshore Surf Shop with Barbie Baron and Scot Tammen (behind Barbie) are members of Team O'Neill when they came to Carlsbad. (Barbie Baron.)

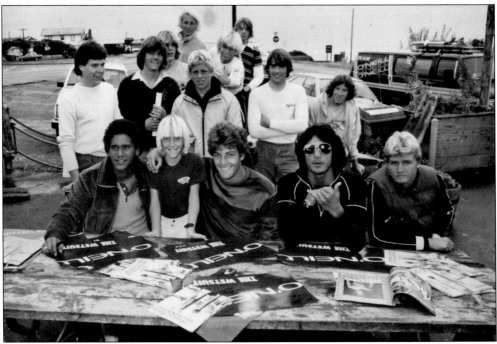

The members of Team O'Neill signing posters in front of Offshore Surf Shop are, from left to right, (first row) Dane Keloha, a local, Shaun Tomson, Louis Ferrer, and Tim Bernardy; locals in back include Scott "Chaney" Chandler (far left) before he took on the big waves. (Barbie Baron.)

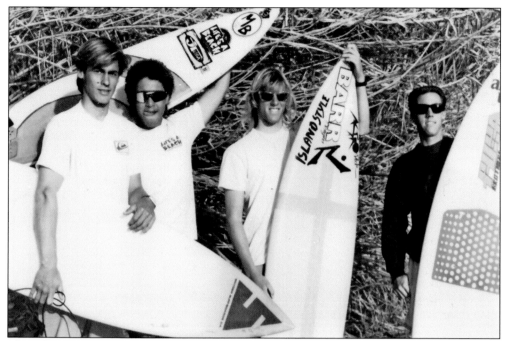

This advertisement for Offshore Surf Shop featured, from left to right, local surfers Rod Bunnel Lopez, Ulises Thomas, Terry Ennis, and Trace Briggs near the bamboo that grew on the bluffs above the beach near the shop. Bamboo is scarce these days but can still be found. (Barbie Baron.)

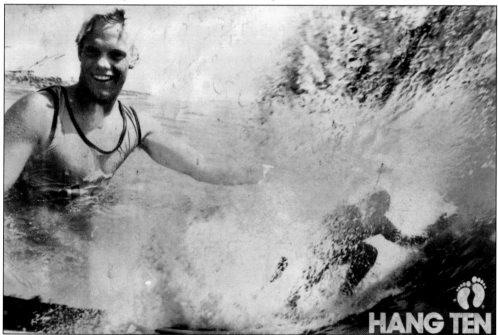

Professional surfer Joey Buran got his start in Carlsbad. Buran began surfing at the age of 12, and by 1975, he was ranked as the top amateur surfer in California. Turning pro in 1978, Buran became California's top pro that year by ranking no. 27 in the world. This photograph is part of a promotion for Hang Ten, one of his sponsors at the time. (Barbie Baron.)

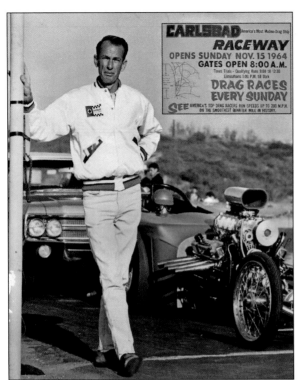

Jim Nelson built and raced his own cars and became a legend in the racing field as both a car builder and driver. He built and drove cars with fellow drag racing legend Mickey Thompson. Nelson co-owned a Carlsbad dragster building company called Dragmasters with partner Dode Martin. Jim also managed the Carlsbad Raceway at the time this 1964 photograph was taken, which shows Jim at the starting line shortly after the raceway opened. (Jim Nelson.)

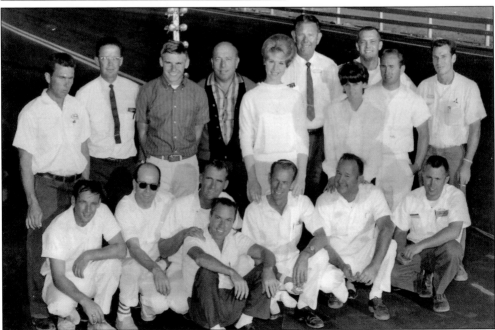

This is the original group that ran the Carlsbad Raceway after it opened in 1964. From left to right are (first row) Vern Martin, Dick Boynton, Lefty Martin, co-owner Larry Grismer, Jim Nelson, Dode Martin, and John Earle; (second row) J. B. Earle, Ford Wynn, co-owner Sandy Belond from Muffler King, Dick Boschetti, unidentified, Bert Perkett, unidentified, Tom Nelson, and two unidentified raceway crew. (Jim Nelson.)

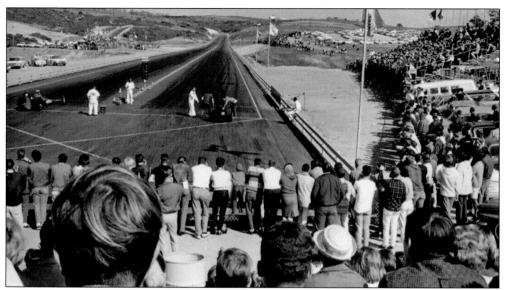

According to the National Hot Rod Association, in 1962, there were 6,616 drag meets with 9,528,225 paid spectators in the United States. Carlsbad Raceway was one of the big stops for this popular sport. Pictured here in 1964 is the Carlsbad Raceway on opening day. (Jeff Grismer.)

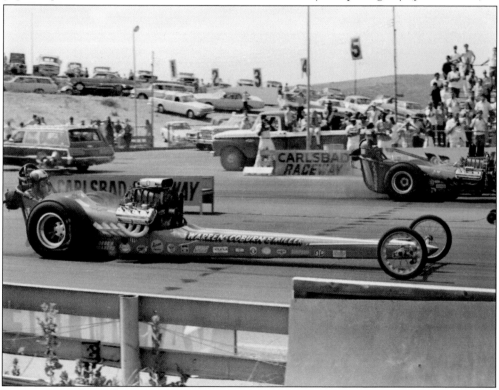

James Warren drove the WCM (Warren, Coburn, and Miller, the car's owners) Top Fueler at the Carlsbad Raceway in 1969. Drag racing at Carlsbad Raceway was reaching its prime when the photograph was taken. Motor sports in the 1960s were more popular than professional baseball and football. (Steve and Bethany Reyes.)

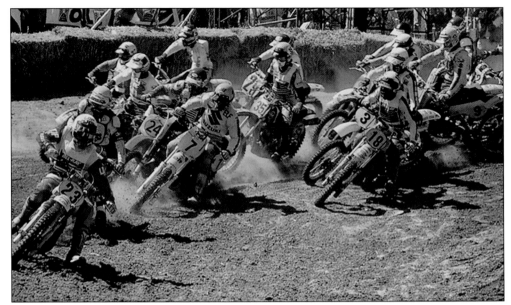

In 1980, the U.S. Grand Prix of Motocross was being completely dominated by European riders, and no American rider had ever won the entire event on U.S. soil. At the time, Marty Moates (No. 23) was an un-sponsored 25-year-old rider from Santee. Marty shocked the Motocross world by battling it out at the end with Brad Lackey and winning the event in front of more than 30,000 people and a nationally televised audience. (Rick Doughty.)

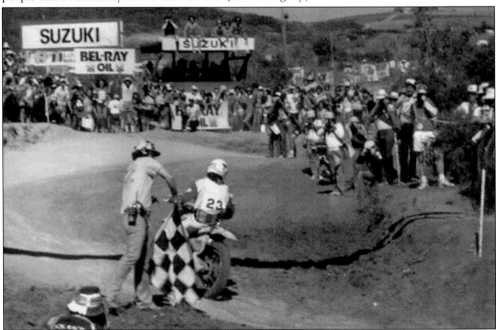

After Moates won, Europeans no longer dominated the sport. U.S. riders—including San Diego–area locals such as Broc Glover, Rick Johnson, and Ron Lechien—would go on to win 13 straight Motocross des Nations world events. At the last U.S. Grand Prix held at Carlsbad Raceway in 1980, Rick Johnson dedicated his win to Marty Moates and call Marty's victory the "greatest day ever." (Rick Doughty.)

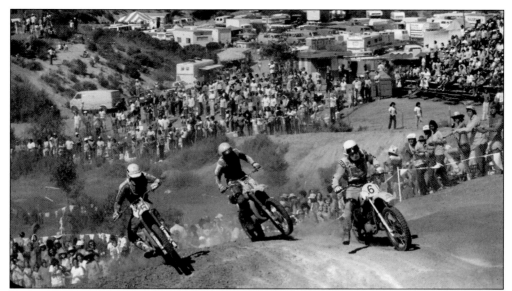

In the 1970s, the Europeans had dominated the 500cc U.S. Grand Prix event at the Carlsbad Raceway with sponsored riders like Roger DeCoster from Belgium and Heikki Mikkola from Finland. Roger had three victories in Carlsbad, and by the mid-1970s, he was considered by many to be the greatest motocross racer of all time. The event was covered by ABC's *Wide World of Sports* with Bruce Jenner as the color commentator. This photograph shows 500cc racers Garret Wolsink (No. 25), Roger DeCoster (No. 1), and Pierre Karsmakers (No. 6) at the Carlsbad U.S. Grand Prix in 1974. (Lee Corkran.)

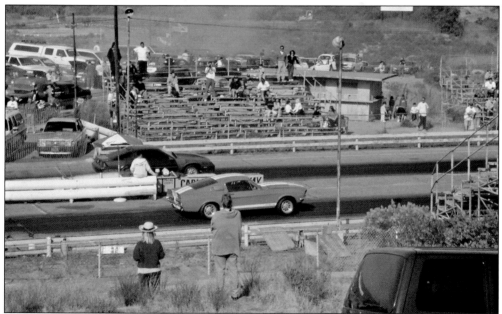

The raceway was accessible to the public on Sundays for people to race against one another. The last days of racing at Carlsbad Raceway featured Bruce Santourian and fellow motor sports enthusiasts drag racing. Bruce headed up an effort to save the raceway that achieved national attention; however, the effort fell short of its goal, primarily because the plans for developing the area were already underway. (Bruce Santourian.)

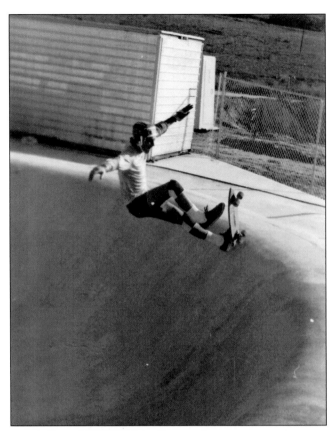

Murray Estes was one of the first to try out the newly opened Carlsbad skate park, known as Mogal Maze. As one of the first to skate pools in the early 1970s, Estes, who rode for Sunset Surfboards, was photographed often and featured in the first issues of *Skateboarder Magazine*. (Dan Sprague.)

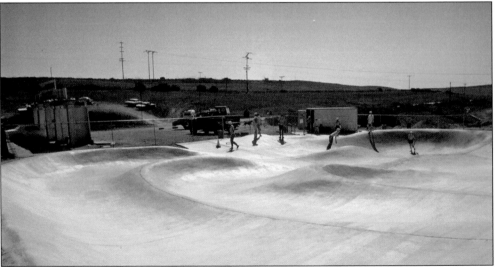

When it opened in 1976, the skate park was the first in the country and gained national notoriety. It was designed and developed by John Malloy. Many skaters have since moved to the area, as well as equipment and apparel manufacturers. In the 2008 ESPN X Games, many of the top finishers called Carlsbad home. John O'Malley, the park's designer, is pictured without the helmet, second from left. At far left is David Dominy of Tracker skateboard trucks, the first truck made for skateboarding. (Lance Smith.)

Because of the lack of vehicle traffic, width of the roadway, hilly terrain, and smooth asphalt, another favorite skating venue was El Fuerte Street in La Costa, featured in this advertisement. Often the site of downhill slaloming competitions, El Fuerte Street became popular, attracting skaters from all across the United States. This advertisement was for the movie *Spinnin' Wheels*, which featured local skaters and skate venues, including El Fuerte. (Jeannie Sprague-Bentley.)

The history of skateboarding dates back to the 1950s, but this style of skating took off when polyurethane wheels replaced the old composite clay ones on earlier skateboards. Early skateboarders used drained pools in the backyards of homes during the drought to replicate a style of surfing using skateboards. The Carlsbad skate park, located near the raceway, was featured in this brochure for the MG Midget. (Jeannie Sprague-Bentley.)

La Costa Resort and Spa opened in 1965 and became the first U.S. resort to introduce a full-service spa. Real estate entrepreneur Allard Roen was said to be an avid golfer. The resort held an annual PGA tour event until 2006. Originally only 90 rooms, the resort was primarily to accommodate prospective Rancho La Costa homeowners to the community. At the time, the area surrounding La Costa was not part of Carlsbad. It wasn't until 1972 that La Costa became part of the city. (Carlsbad History Room, Carlsbad City Library.)

The La Costa Resort and Spa was built on the site of two former land grants, the Agua Hedionda to the north and the Rancho Las Encinitas to the south in the area known as Green Valley. Allard Roen, the developer, was said to have discovered the land while on horseback, thus the resort had an equestrian center. (Carlsbad History Room, Carlsbad City Library.)

Besides equestrian activities and golf, tennis was also a focus at the resort. After his playing career, Pancho Segura, the leading tennis player of the 1940s and 1950s, served as the pro at La Costa. The club also hosted an annual World Tennis Association tour event until 2007. Pictured from left to right are tennis legends Pancho Segura, Jimmy Conners, and Bobby Riggs at La Costa. (Bobby Riggs Tennis Club and Museum.)

The Four Seasons Aviara Resort is also located in La Costa on the north shore of the Batiquitos Lagoon. Walking trails surround the lagoon, a nature preserve, and the 18-hole golf course. The resort has pool, tennis, and spa amenities. This photograph shows a westward view of the resort prior to landscaping, just before it opened in the 1990s. (Four Seasons Aviara Resort.)

During a freak snowstorm, only one of two recorded since the early 1900s, Johnny and Janet McKaig and their family awoke to snow at their home on Skyline Drive, as did many on the coast and inland North County on December 13, 1967. Johnny McKaig's hand-carved tiki on Skyline Drive was an unusual sight even without snow. The McKaigs' artistic endeavors were varied. Johnny's detailed mosaic of the city emblem hangs in the council chambers inside city hall. His tiki carvings were seen throughout the city, and his barber pole graced the downtown for all the years he worked there as a barber and volunteer fireman. (Johnny and Janet McKaig.)

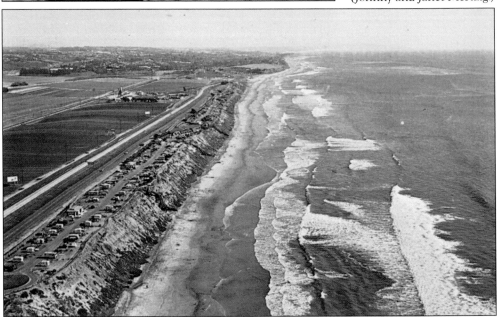

One of the best-kept secrets is that of "backyard" camping for local residents of Carlsbad. Once known as La Costa Downs, a private campground, Carlsbad State Beach is now state-run. The California State Parks took over 10 coastal acres in 1933 and supplied two lifeguards, John Oakley and Chuck Freeburn, in 1955. Now the entire coastline, from Pine Street to South Carlsbad State Beach, is state-run. (Jack Greelis.)

Eight

CARLSBAD GROWS UP

By 2000, the city of Carlsbad had grown to nearly 80,000 residents, and by the middle of the decade, it had reached 100,000.

Now often referred to in quadrants, each separate community within the city has continued to grow while retaining its own unique personality, and the Olde Carlsbad "Village by the Sea" is still the heart of the city.

Working farms, ranches, old barns, and horses can still be found just off the beaten path east of El Camino Real, and just over the hill to the west, the sparking blue ocean still beckons.

But Carlsbad has always been able to reinvent itself.

Today the Flower Fields serves as a backdrop to LEGOLAND, the Gemology Institute of America, and the National Association of Making Music. The city has continued to support the arts, welcoming traveling art exhibitions, T.G.I.F. music in the parks, and performing arts to the new Village Arts Theatre.

Perhaps more than any city in Southern California, Carlsbad continues to cultivate and attract a variety of athletes, many from the two public high schools.

Professional surfers, skate legend Tony Hawk, and skater and snowboard Olympic medalist Shaun White, as well as top X Game medalists, live in the area.

Several athletes have gone on to market their lifestyles and set up shop in Carlsbad. Judie Sheppard Missett's Jazzercise is headquartered in Carlsbad. Runners, swimmers, and cyclists participate in the three big events held each year, attracting names like Steve Scott and Michellie Jones.

Equestrian activities can still be found along the back roads and trails, and Carlsbad is home to Triple Crown winner Julie Krone. Two resort courses, an executive course, a newly opened 18-hole public course, and large golf manufacturers like TaylorMade-adidas, Callaway, and Titleist are all headquartered in Carlsbad. The Home of the Avocado turned Flower Capital is now often referred to as the Golf Capital.

Now preservation of open space and trails top the city's agenda as development plans reach their goals. Carlsbad continues to move forward, while glancing back, moving closer to its objective of providing residents a place where they can "live, work, and play."

Despite the city's growth, the village of Carlsbad has managed to maintain its distinction of being a coastal community with a small-town feel, one that rewrites history each day.

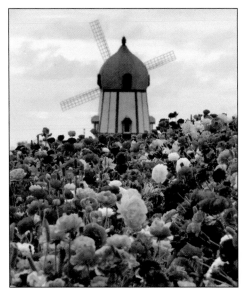
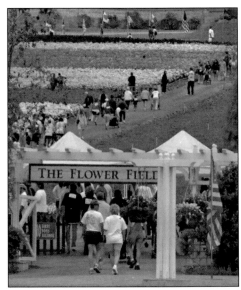

In August 1993, the Carltas Company, the land management division for the Ecke family, entered into a joint venture to take over 50 acres of ranunculus from the Frazee family. A relationship between Carltas and Mellano and Company, from the San Luis Rey valley, produced the landmark tourist attraction known as the Flower Fields. Nearby, one of the most photographed landmarks in the city, the windmill, originally part of Pea Soup Andersons restaurant, is now part of a hotel and serves as a visual link between the blue Pacific Ocean and the colorful Flower Fields behind. (Both, Lizbeth Ecke.)

The Eckes are still involved in the family business. Lizbeth, pictured with her husband, David (left), works with the popular Flower Fields attraction in Carlsbad, and Paul Ecke II (right), pictured with his wife, Julie, is still involved in the day-to-day operation, working with the poinsettias on Saxony Drive. (Lizbeth Ecke.)

The winds of change are always blowing in Carlsbad but have managed to leave some areas of the city untouched. A northern aerial view of the Strawberry and Flower Fields shows their proximity to Car Country Carlsbad, a new shopping area, and the Grand Pacific Palisades and new Sheraton hotels. In the 1990s, the city voted to leave the Flower Fields untouched by development. Nearby flower growers who have displayed at the International Floral Trade Center (below), a unique wholesale warehouse west of the Flower Fields, will move in 2009. (Both, Jeannie Sprague-Bentley.)

LEGOLAND California opened in 1999. The park has 15,000 LEGO models and more than 35 million LEGO bricks. The Sea Life Aquarium opened in 2008 and covers sea life found in the open oceans and the estuaries that feed into them. The aquarium features LEGO elements in its design. (LEGOLAND California Resort.)

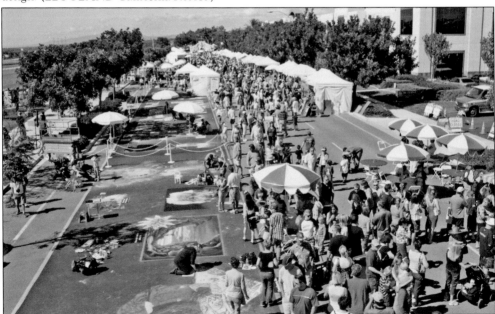

Thousands stroll past the colorful chalk drawings that line the streets every fall above the Flower Fields and the blue Pacific during ArtSplash. Since 2003, artists old and new have created one-of-a-kind street paintings, while visual and performing artists provide entertainment at the two-day festival of music, food, and fun. The event is sponsored in part by the city cultural arts office and the Rotary Club of Carlsbad and benefits arts programs in the city schools. (ArtSplash.)

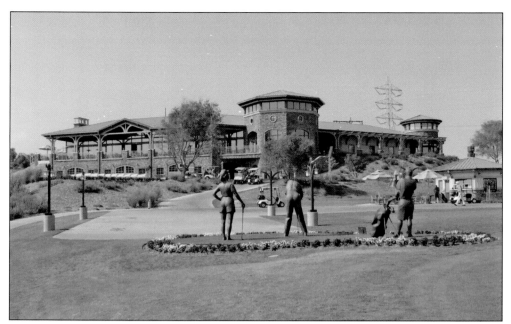

The Crossings at Carlsbad opened in 2007. It is the city's first municipal golf course, designed by Greg Nash and run by KemperSports. The 18-hole course is set in the hills and boasts a 28,000-square-foot clubhouse. In the first year of operation, it received national acclaim when *Golf Magazine* featured it as one of the "Top 10 New Courses You Can Play." (Jeannie Sprague-Bentley.)

The Crossings at Carlsbad opened in large part due to the efforts of Jim Smith, a founding member of the Carlsbad Golf Association. Smith wrote a letter to the city council and the mayor. Twenty-two years later, just shy of his 90th birthday, Jim Smith was able to attend the ribbon-cutting ceremony with Mayor Pro Tem Ann Kulchin (center), council members Matt Hall, Julie Nygaard, and Mark Packard, nephew of former congressman Ron Packard, and supporter Bill Hartley. (Sam Wells.)

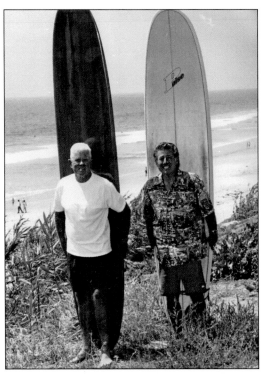

Surfing legends Carl Miller, coach of the Carlsbad High School surf team, and Doug Tico, former lifeguard (right), were recognized by the City of Carlsbad for their contributions to the sport and featured in a documentary titled *The Art of Surfing in Carlsbad from 1950 to 2002.* They were proclaimed by the city as "Surfers of the Century." (Barbie Baron.)

From left to right, Jeff Warner and his son Jack, Bob Hecklinger, Ron Hecklinger, and Frank Hecklinger pose with a Tamarack board in 2006 at Legends Surf. (Legends Surf.)

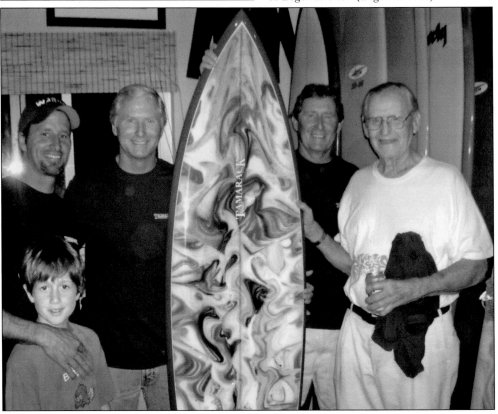

Pictured here with professional surf legend and Offshore Surf Shop owner Barbie Baron is Tom Morey, the surfer and entrepreneur who made the first Boogie Boards. When Tom Morey was just starting his business, making boards out of his garage not far from the beach, Barbie Baron had just opened her shop, leading to a lifelong friendship. Tom Morey sold the first Morey Boogie Boards from his Oak Avenue address in the early 1970s. The first ones were kits that had to be put together. (Both, Barbie Baron.)

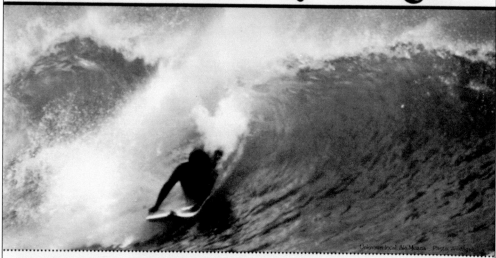

Enjoy A Morey Boogie

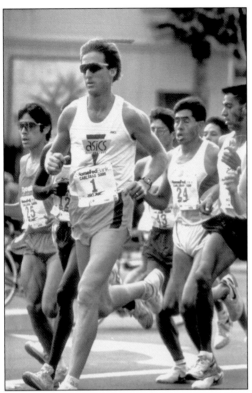

The Carlsbad 5000 began in 1986. Steve Scott, one of the greatest milers in American history, is a three-time Olympian and three-time winner of the Carlsbad 5000, setting two world-best times for 5,000 meters on the road. Scott was a founder of the race, helped design the course, and still holds several age records. The Carlsbad 5000, know as the "Party by the Sea" is the world's fastest 5k, as 16 world records have been set in Carlsbad. (Elite Racing.)

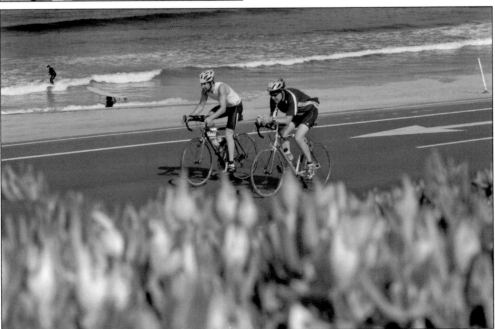

The Carlsbad Triathlon started in 1981 and has the distinction of being one of the top five longest-running triathlons in the world. The event is limited to 1,000 athletes. Pictured here are two riders participating in the biking portion of the race along Carlsbad Boulevard just north of Carlsbad State Beach campground. (Patrice Malloy.)

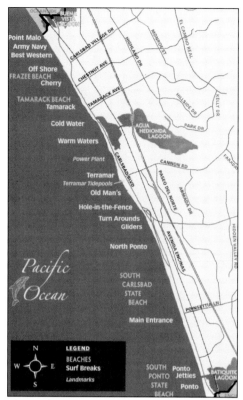

Miles of state-run beaches are used year-round for surfing. The map shows some of the best breaks known to locals. The State Beach Locals is a "group of guys who grew up surfing together" at the state beach near Offshore Surf Shop and are still actively involved in "caring for the beach" where they surf. Members now have families and careers in the business but still work for the Surfrider Foundation and hold annual surf contests, like the one held in memory of Banning Capps. (All, Ulises Thomas.)

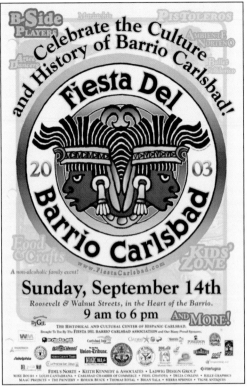

The Fiesta del Barrio was first held in 1991 and was resurrected once again in 2001. Ofie Escobedo and her sister, Connie Trejo, who own Lola's 7-Up Mexican Market and Deli, were the driving force behind the event, held each year in front of Lola's in the "heart of the Barrio," on Walnut Avenue and Roosevelt Street. The event, put on by the Barrio Carlsbad Association and Fiesta del Barrio Association, raised money for scholarships. (Lola's Market.)

From left to right, Ofie Escobedo, Connie Trejo, and Frances Jauregui-Moreno took over their parents' market and renamed it Lola's 7-Up Mexican Market and Deli. Local neighbors and members of the business community join skaters, surfers, and students in a line for their authentic "homemade" meals. It is now the oldest continuous business in Carlsbad, attracting a whole new generation to leave their heart in the Barrio. (Ofie Escobedo.)

After Shaun White, who grew up in Carlsbad, won the gold medal in snowboarding in the 2004 Winter Olympics, the city honored him with a city proclamation at city hall. Pictured from left to right are Mayor Bud Lewis, Mayor Pro Tem Ann Kulchin, Shaun White, Councilman Mark Packard, and Councilwoman Noreen Sigafoose. Packard's father was longtime congressman Ron Packard. The tile mosaic hanging in the council chambers was made by Johnny McKaig, who passed away in 2009. (City of Carlsbad.)

Chamber of commerce president and chief executive officer Ted Owen (left) and longtime Carlsbad mayor Bud Lewis (center), along with 2008 chairman of the board Lou Storrow, pose at the annual business awards luncheon put on by the chamber of commerce. (Carlsbad Chamber of Commerce.)

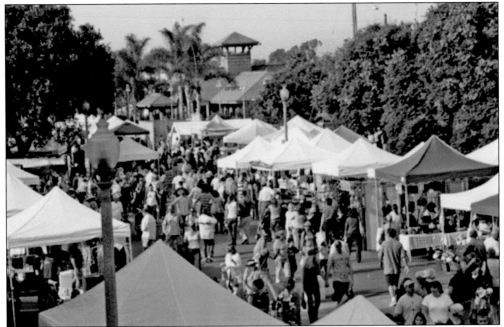

The Carlsbad Chamber of Commerce started an annual village street fair in 1974. The event has grown to one of the largest in the state, with over 100,000 in attendance and more than 900 booths showcasing arts and crafts. The City of Carlsbad has always been supportive of the arts, with a department dedicated to cultivating the arts in the city. (Carlsbad Chamber of Commerce.)

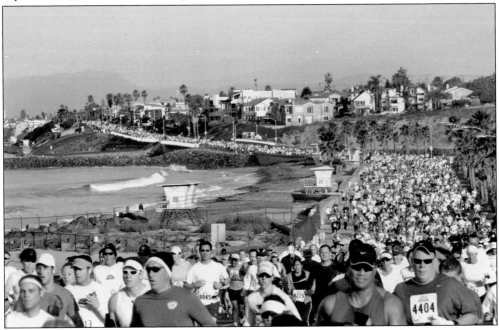

Since the 1980s, The Carlsbad Marathon and Half-Marathon has grown and now attracts over 10,000 participants every year and benefits the Charities in Motion Foundation, a collaboration of nonprofit organizations. The marathon course starts at Westfield Plaza in the north portion of Carlsbad and covers the scenic Carlsbad coastline along Carlsbad Boulevard. (Photo Art.)